ACRYLIC PAINTING
with LEE HAMMOND

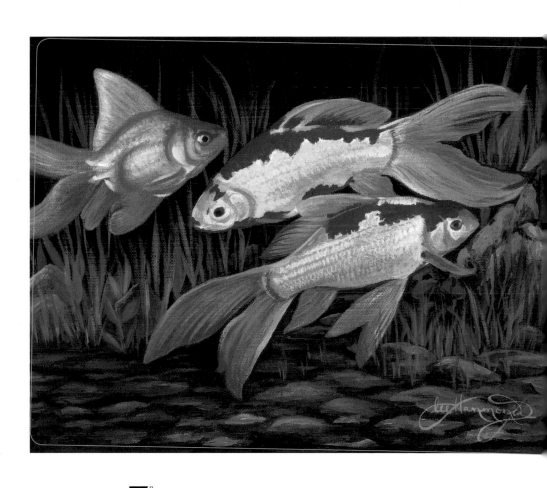

NORTH LIGHT BOOKS
CINCINNATI, OHIO
www.artistsnetwork.com

Acrylic Painting With Lee Hammond. Copyright © 2006 by Lee Hammond. Printed in China. All rights reserved. No part of this book may be reproduced in any form or by any electronic or mechanical means including information storage and retrieval systems without permission in writing from the publisher, except by a reviewer who may quote brief passages in a review. Published by North Light Books, an imprint of F+W Publications, Inc., 4700 East Galbraith Road, Cincinnati, Ohio, 45236. (800) 289-0963. First edition.

Other fine North Light Books are available from your local bookstore, art supply store or direct from the publisher.

11 10 6 5 4

Distributed in Canada by Fraser Direct
100 Armstrong Avenue
Georgetown, ON, Canada L7G 5S4
Tel: (905) 877-4411

Distributed in the U.K. and Europe by David & Charles
Brunel House, Newton Abbot, Devon, TQ12 4PU, England
Tel: (+44) 1626 323200, Fax: (+44) 1626 323319
Email: postmaster@davidandcharles.co.uk

Distributed in Australia by Capricorn Link
P.O. Box 704, S. Windsor NSW, 2756 Australia
Tel: (02) 4577-3555

Library of Congress Cataloging-in-Publication Data

Hammond, Lee
 Acrylic painting with Lee Hammond ; [edited by Amy Jeynes and Jolie Lamping].—1st ed.
 p. cm.
 Includes index.
 ISBN-13: 978-1-58180-709-7 (pbk: alk. paper)
 ISBN-10: 1-58180-709-0 (pbk. : alk. paper)
 1. Acrylic painting—Technique. I. Jeynes, Amy. II. Lamping, Jolie. III. Title.
 ND1535.H343 2006
 751.4'26--dc22

 2005014222

Editors: Amy Jeynes and Jolie Lamping Roth
Material and technique photographer: Dustin Weant
Cover designer: Nicole Armstrong
Page designer: Guy Kelly
Interior production: Dragonfly Graphics LLC
Production coordinator: Mark Griffin

F+W PUBLICATIONS, IN

Dedication

This book is dedicated to all of the lucky people who take the time to make art an integral part of their lives. Through art, we express our thoughts, illustrate our lives, cope with hardships and share all of life's beauty and challenges. Thank you for buying my books and allowing me to share with you the joy and happiness I feel every day living my life as an artist. Without my students and readers, it would not have the same meaning.

Acknowledgments

This is my first book on painting techniques, and I couldn't be more excited about it. With so many drawing books under my literary belt, it is a true joy to expand into a new adventure and show you how I paint. I can't thank all of the wonderful people at North Light Books enough for allowing me the opportunity to spread my artistic wings.

I also want to extend a huge thank-you to Amy Jeynes and Jolie Lamping Roth for such a wonderful job of editing. It was a joy working with them!

Last but not least, I want to thank my photographer, Dustin Weant, for his help and friendship.

Metric Conversion Chart

To convert	to	multiply by
Inches	Centimeters	2.54
Centimeters	Inches	0.4
Feet	Centimeters	30.5
Centimeters	Feet	0.03
Yards	Meters	0.9
Meters	Yards	1.1
Sq. Inches	Sq. Centimeters	6.45
Sq. Centimeters	Sq. Inches	0.16
Sq. Feet	Sq. Meters	0.09
Sq. Meters	Sq. Feet	10.8
Sq. Yards	Sq. Meters	0.8
Sq. Meters	Sq. Yards	1.2
Pounds	Kilograms	0.45
Kilograms	Pounds	2.2
Ounces	Grams	28.4
Grams	Ounces	0.04

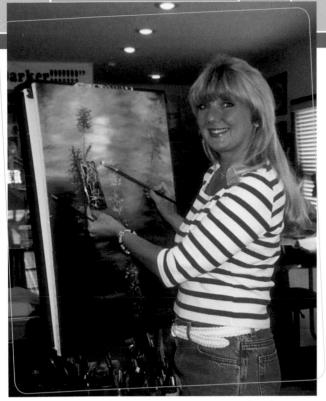

Lee Hammond painting in her studio in Overland Park, Kansas.

About the Author

Polly "Lee" Hammond is an illustrator and art instructor from the Kansas City area. She owns and operates a private art studio called Take It To Art™, where she teaches realistic drawing and painting.

Lee was raised and educated in Lincoln, Nebraska, and she established her career in illustration and teaching in Kansas City. Although she has lived all over the country, she will always consider Kansas City home. Lee has been an author with North Light Books since 1994. She also writes and illustrates articles for other publications such as *The Artist's Magazine*.

Lee is continuing to develop new art instruction books for North Light and has also begun illustrating children's books. Fine art and limited-edition prints of her work will also be offered soon.

Lee lives in Overland Park, Kansas, along with her family. You may contact Lee via e-mail at Pollylee@aol.com or visit her website at www.LeeHammond.com.

Foreword

There are many books about the many ways one can create a work of art. But what makes each painting different? If we all painted the same way or viewed things in the same fashion, we would need only one book to learn from. But life isn't that simple, thank goodness! The reason we have so many books to choose from is that each of us is unique. For that reason, especially in art, there is clearly no real "right" or "wrong" way—just many different and wonderful approaches. As creative people, we can experiment and choose the techniques that fit our personal styles.

This book is all about my technique for painting with acrylics. I will never say that it is the right way or the only way to paint. If you have never painted with acrylics before, this book will be a good introduction to the medium. As you paint the projects in this book, you may find that my approach feels natural to you, or you may discover your own way of painting. Have fun buying other books on the subject of acrylics (there are many great ones out there) and comparing how each artist tackles the medium. Explore and experiment. Learn from all you do so that you can make your own unique statement with your art. Most of all, relax and enjoy the process, and have a wonderful time with your new adventure!

lee

TABLE OF CONTENTS

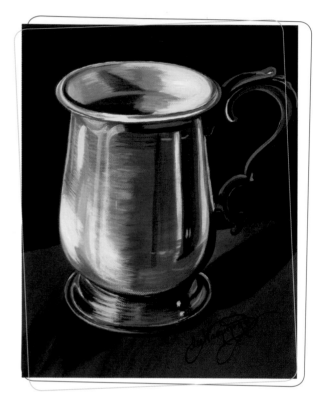

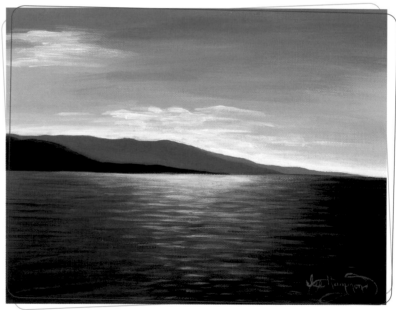

Introduction

I have been writing art technique books for more than a decade. This book, however, is my first one about painting rather than drawing. Being an art instructor, I pushed myself as I was creating the art for this book, taking note of the differences between my approaches to painting and drawing. I also noticed that I used some of the same thought processes and applications with both. When I create my books, I often use the illustrations as examples in my art classes. I allow my students to ask questions while they watch me work, and I use their questions to guide me as I write.

As my students watched me paint, we all came to a powerful conclusion. It is very important to learn to draw well if you want to paint well. Many painters do not have a solid drawing background, and it often shows. Those who do produce paintings with accurate perspective and good dimensional form.

This book is a collection of colorful projects designed to help you learn to paint with acrylics. The more than 25 step-by-step projects will also give you a wide range of subject matter to enjoy. Some of the projects may look complex, but remember that painting with acrylic is all about painting in layers. Since acrylics dry rapidly, it is easy to keep adding details or to cover up previous applications a little at a time. You're never "stuck" when you work with acrylic paint; it is a very forgiving medium.

It is also important to remember that every painting goes through what I call "the awkward stage." The initial layers of a painting, when you are essentially creating a "color map" to follow, will be sloppy, and the watered-down pigments will look weak. Don't become discouraged and stop too soon! By adding more layers and details with thicker paint, you'll achieve the realistic look you're after.

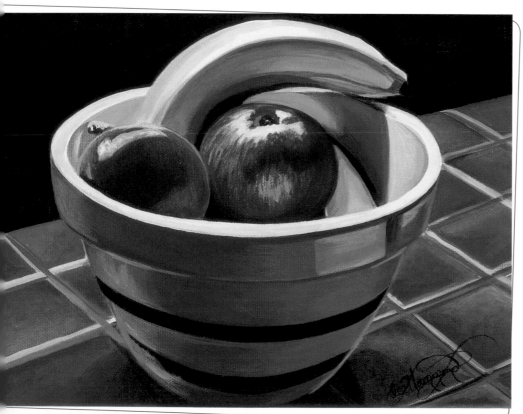

PATIENCE HAS ITS REWARDS

This is an example of what you can do if you keep practicing. If you look closely, you will see places where colors are placed on top of other colors. After you have painted some of the projects in this book, you may want to come back to this painting and try to paint it yourself.

Bowl of Fruit
9" × 12" (23cm × 30cm)

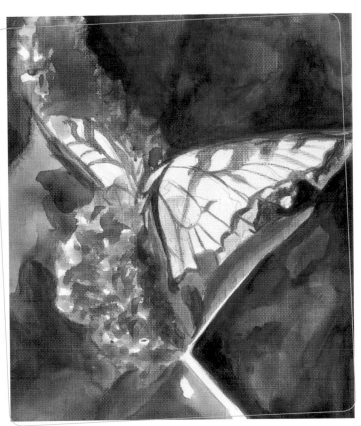

THE AWKWARD STAGE

This example shows the typical stopping point for most beginning acrylic painters. The paint looks watercolor-like, the colors look weak and the canvas shows through. However, this painting looks unfinished because it is. This important "awkward stage" is merely a color map for the more detailed layers to come.

DON'T GIVE UP

This painting looks much more professional. Thicker, undiluted paint and layered details create a realistic look. The canvas now is totally covered, and the colors are much more vibrant. Everything comes together in the final stages of the painting. The effort is definitely worth it!

Tiger Swallowtail on a Butterfly Bush
16" × 12" (41cm × 30cm)

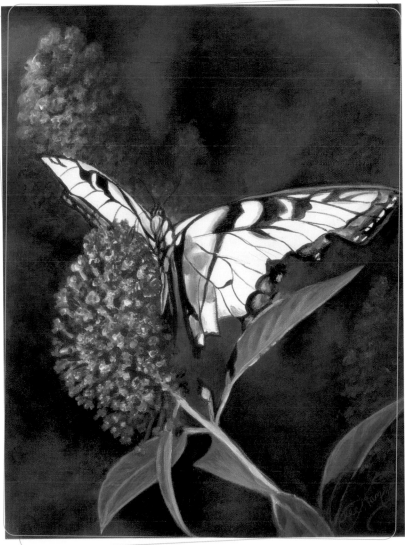

getting started

paints, tools and supplies

YOU DON'T NEED A ROOM FULL OF SUPPLIES TO BEGIN painting with acrylics. I use a very small number of colors on my palette and only a few different brushes. Keeping it simple makes me feel more relaxed in my work area.

A tackle box is a great place to keep your painting supplies. It's easy to carry with you when you want to paint on location, and it acts as a storage unit when you're not painting. Have fun creating your own custom acrylic painting kit! Everything you'll need to get started is listed on this page.

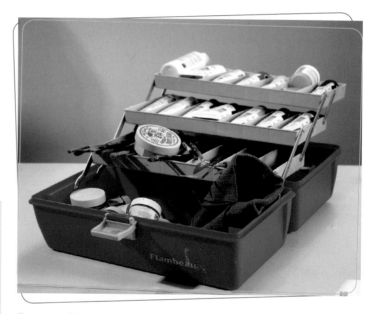

PAINTS, TOOLS AND SUPPLIES
A simple set of tools and a limited palette of colors are all you need to start painting in acrylics. A tackle box makes a great storage unit.

Start-Up Kit

Below is a list of essentials you should have on hand to get you started on the painting projects in this book. Happy painting!

Paints: Prussian Blue, Ivory Black, Titanium White, Burnt Umber, Cadmium Yellow Medium, Cadmium Red Medium, Alizarin Crimson.

Surfaces: Prestretched canvases, canvas panels and/or canvas sheets.

Brushes: ¾-inch (19mm) filbert, no. 3 filbert, no. 4 filbert, no. 6 filbert, no. 8 filbert, no. 2 liner, no. 1 liner, no. 2/0 liner, no. 2/0 round, no. 2 round, no. 4 round, no. 6 round, no. 6 flat, no. 4 flat, hake.

Palette: Plastic, with a lid (or improvise your own—see page 15).

Other Materials: Cloth rags, wet wipes, cans or jars, spray bottle of water, palette knife, masking or drafting tape, mechanical pencil with 2B lead, ruler, kneaded eraser.

What Is Acrylic Paint?

Acrylic paints are made of dry pigment in a liquid polymer binder, which is a form of acrylic plastic. Acrylics are water-based, so they require no paint thinners as oil paints do, though they can be diluted with water while painting.

Acrylic paint dries quickly to a waterproof finish. Because of its plastic, waterproof quality, it can be used on a variety of surfaces. It is a favorite for painting on windows, outdoor signs, walls and fabric. It is permanent, so items painted with it are washable.

Varieties of Acrylic Paint

Many varieties of acrylic paints are available. Your choice depends partly on the project you're planning to do. There are acrylics formulated for folk art, fine art, even for painting on fabric, walls or signs.

For the projects in this book, look for paints labeled "high-viscosity" or "professional grade." Other kinds of acrylic paint will be too thin, with a pigment concentration too low for satisfactory results.

Student-grade paints and those in squeeze bottles generally have a lower concentration of pigment. The pigment is still high quality; there is just a little less of it. Many student grades are so good that professionals use them as well. They are very fluid, easy to work with and easy to mix.

Professional-grade paints have a higher concentration of pigment. They are usually a bit thicker than student-grade paints, and their colors may seem more deep and vivid. Professional grades are found in tubes or jars.

You will find paints in tubes, jars, and squeeze bottles. I prefer using paint from a jar rather than from a tube or bottle. Acrylic paint dries quickly, so if I have some uncontaminated color left over on my palette, I return it to the jar to avoid wasting it. This is not possible with paint from a tube or bottle. I also like jars because I can mix my own custom colors for a particular painting and store them in separate jars. This is helpful if you are working on a large project and need to keep your colors consistent as you work.

For the projects in this book, I used a palette of seven colors: Ivory Black, Cadmium Red Medium, Burnt Umber, Cadmium Yellow Medium, Alizarin Crimson, Prussian Blue and Titanium White. (For more information on palette colors and color mixing, see chapter two, pages 18–19.)

TUBES, JARS OR BOTTLES?

Acrylic paints come in tubes, jars and squeeze bottles. I prefer to use the jars, so I can reuse leftover paint. I can also mix special colors for specific projects, and place those colors in empty jars.

Paint Properties

As we just discussed, each form of paint—jar, tube or squeeze bottle—has different characteristics. Once you've selected the paint you prefer, you will find that individual colors have their own properties as well.

Opacity: Some colors will cover better than others, appearing more opaque, while some will be more transparent. With time and practice, you'll get to know your paints. Play and experiment first by creating some color swatches like the ones on this page. This will give you a better understanding of how each color on your palette behaves.

The swatches on this page show how some colors are opaque and completely cover the canvas, while others are more transparent and seem streaky.

Permanence: Certain colors are more prone to fading over time than others. Most brands will have a permanency rating on the package to let you know what to expect. A color with an "Excellent" rating is a durable color that will hold its original color for a long time. A color rated as "Good" or "Moderate" will have some fading, but not a huge difference over time. A color rated as "Fugitive" will tend to fade significantly. You can see this most often with yellows and certain reds. Try to avoid fugitive colors, but regardless of a color's permanence rating, never hang a painting in direct sunlight. Ultraviolet rays in sunlight are the primary cause of fading.

Toxicity: Good-quality paint brands will include some toxic colors. Some of the natural pigments that produce vivid colors are toxic, such as the Cadmium pigments and some blues. Never swallow or inhale these colors. Certain colors should never be spray applied; check the label. If you're working with children, always find a brand that substitutes synthetic, manufactured pigments for the toxic ones.

ALIZARIN CRIMSON
This red is dark but transparent in nature. It has a streaky appearance, letting some of the canvas show through.

CADMIUM RED MEDIUM
This red is opaque and completely covers the canvas. Can you see the difference between this and the Alizarin Crimson?

PRUSSIAN BLUE
This blue is dark but transparent.

PRUSSIAN BLUE + TITANIUM WHITE
Just by adding a touch of Titanium White to Prussian Blue, you can create an opaque version of it.

tip

Don't Eat Your Paint
Because some colors are toxic, never hold brushes in your mouth. Also, use a jar or other distinctive container to hold water for painting so that you never mistake a cup of paint water for iced tea!

Thinning Acrylics With Water

Mixing acrylic paint with water makes it more transparent. This is useful for the beginning stages of a painting, when you are creating the basic pattern of colors for a painting.

Thinned acrylics are often used to create a look very similar to that of watercolor paints. The difference is that acrylic paint is waterproof when it dries. You can add more color without pulling up previous layers. Regular watercolor will re-hydrate when wet paint is applied on top of it, usually muddying the colors.

JUST THE BEGINNING

This example shows how I begin my painting. It looks very underdeveloped, but it gives me a good foundation to work on. The colors of the flower and the background are established, allowing me to then add more color for the details.

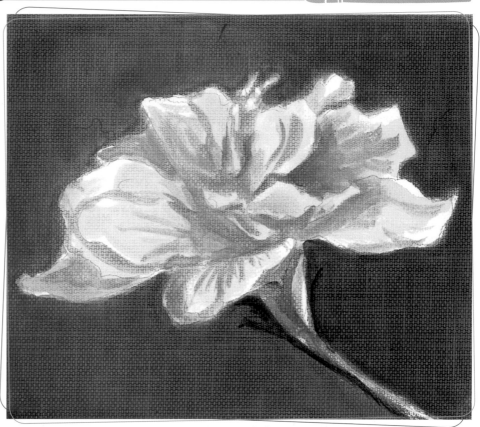

THE FINISHED PAINTING

The second example shows how I reduced the amount of water I added to the paint, and added details. The thicker paint covers up the existing layer. You can see how the look of the paint changes here. The full-strength paint is much more opaque.

Study of a Flower
$5^1/_2$" × $7^1/_2$"
(14cm × 19cm)

Choosing Brushes

Read all about brush basics here, and see the list on page 8 for the basic set of brushes needed for the projects in this book.

Bristle Type

The way paint looks when applied to canvas largely depends on the type of brush you use. Brushes come in a variety of bristle types.

Stiff bristle: These brushes are made from boar bristle, ox hair, horsehair or other coarse animal hairs.

Sable: These brushes are made from the tail hair of the male kolinsky sable, which is found in Russia. This very soft hair creates smooth blends. The scarcity of the kolinsky makes these brushes expensive, but they are worth it!

Squirrel hair: These soft brushes are a bit fuller than sable brushes, and are often used for watercolor because they hold a lot of moisture.

Camel hair: This is another soft hair that is used frequently for both acrylic and watercolor brushes.

Synthetic: Most synthetic bristles are nylon. They can be a more affordable substitute for natural-hair brushes, but paint is very hard on them. They tend to lose their shape and point faster than natural hair brushes. Good brush cleaning and care (see page 13) is essential to make synthetic brushes last.

Natural-hair brushes can be quite pricey. However, if cleaned properly, they will last longer than synthetic ones.

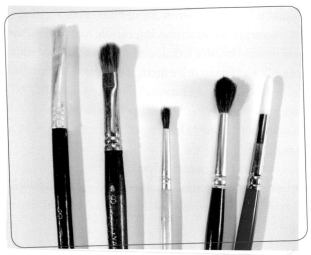

From left to right: stiff bristle, sable, squirrel hair, camel hair and synthetic bristle types.

Brush Shape

Brushes come in different shapes, and some shapes are better for certain paint applications. Below is a quick list of the different brush shapes and the best uses for each.

Flat: A flat brush is used for broad applications of paint. Its wide shape will cover a large area. The coarse boar-bristle type is a stiff brush that can be used to literally "scrub" the paint into the canvas. A softer sable or synthetic bristle is good for smooth blending with less noticeable brush marks.

Bright: Brights are very similar to flats; however, the bristles are a bit longer, which gives the brush more spring.

Round: Use round brushes for details and smaller areas. The tip of a stiff bristle round is good for dabbing in paint or filling in small areas. A small soft round can be used in place of a liner brush for creating long straight or curved lines.

Filbert: This brush shape is my personal favorite. Also known as a "cat's tongue," the filbert is useful for filling in areas, due to its rounded tip.

Liner: The liner's small, pointy shape makes it essential for detail work. You can create tiny lines and crisp edges with a liner.

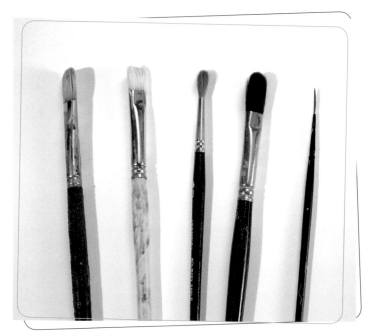

From left to right: flat, bright, round, filbert and liner brush shapes.

Long or Short Brushes?

Long-handled brushes are designed for use while standing at an easel, so you can paint at arm's length and have a better overall view of your work. Short handles are better for painting while seated or for working on small details.

Brush Maintenance

Acrylic paint is hard on brushes. Remember, once acrylic paint dries, it is waterproof and almost impossible to remove. Paint often gets into the brush's ferrule (the metal band that holds the bristles in place). If paint dries there, it can make the bristles break off or force them in unnatural directions. A brush left to dry with acrylic paint in it is as good as thrown away.

Follow these pointers to keep your brushes like new for as long as possible.

- Stick to a strict and thorough brush-cleaning routine. My favorite cleaning procedure is shown on this page. (Note: Some paint colors stain synthetic bristles. This staining is permanent, but normal and harmless.)
- Never leave a brush resting in a jar of water. This can bend the bristles permanently. It can also loosen the ferrule, causing the bristles to fall out. (Sometimes a brush with five hairs is good for small details, but not if the poor brush started out with a hundred!)
- Always store your brushes handle-down in a jar, can or brush holder to protect the bristles.

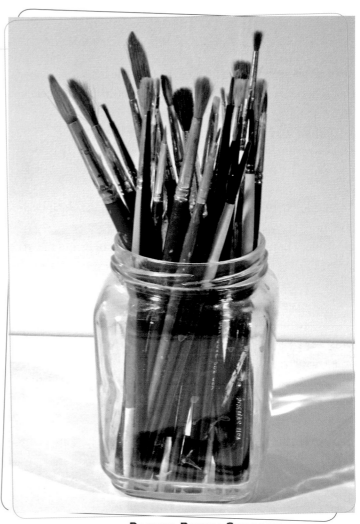

PROPER BRUSH STORAGE
Always store brushes with their bristles in the "up" position!

tip

How to Clean Brushes

1. Swish the brush in a clean jar of water to loosen any remaining paint.
2. Take the brush to the sink and run lukewarm water over it.
3. Work the brush into a cake of The Masters Brush Cleaner and Preserver until it forms a thick lather. At this point, you will notice some paint color leaving the brush.
4. Gently massage the bristles between your thumb and fingers to continue loosening the paint.
5. Rinse under the warm water.
6. Repeat steps 3 to 5 until no more color comes out.
7. When you are sure the brush is clean, apply some of the brush cleaner paste to the bristles and press them into their original shape. Allow the paste to dry on the brush. This keeps the bristles going the way they are intended and prevents them from drying out and fraying. It's like hair conditioner for your brushes! When you are ready to use the brush again, simply rinse the soap off with water.

MY FAVORITE BRUSH CLEANER

The Masters Brush Cleaner and Preserver will remove all of the paint from your brushes and condition the bristles. I've used it for many years and swear by it.

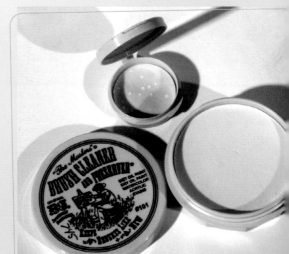

Painting Surfaces

Many students ask me what the best painting surface is. That depends on your preference and what kind of painting you are doing. Acrylic paint can be used on everything from fine art canvases to wood, fabric, metal and glass. For the sake of this book, I will concentrate on surfaces normally used for paintings.

Stretched Canvas

Stretched canvas provides a professional look, making your work resemble an oil painting. Stretched canvas is easily framed and comes in standard frame sizes from mini (2" × 3" [5cm × 8cm]) to extra large (48" × 60" [122cm × 152cm] or larger). You will notice a bit of "bounce" when applying paint to stretched canvas.

Stretched canvas comes "primed," which means it is coated with a white acrylic called gesso to protect the raw canvas from the damaging effects of paint.

Stretched canvas can be regular cotton duck, excellent for most work; extra-smooth cotton, often used for portrait work; or linen, which is also smooth.

Canvas Panels

Canvas panels are canvas pieces glued onto cardboard backings. They are a good alternative to stretched canvas if you would prefer to spend less. A canvas panel is very rigid and will not give you the bouncy feel of painting on stretched canvas.

With canvas panels, unlike stretched canvas, you have the option of framing with a mat. A colored mat can enhance the look of artwork. A canvas panel also allows you to protect your painting with glass.

Canvas Sheets

Another alternative is canvas sheets. Some brands are pieces of actual primed canvas, not affixed to anything. Others are processed papers with a canvas texture and a coating that resembles gesso. Both kinds can be purchased individually, in packages or in pads.

With canvas sheets, as with canvas panels, framing can be creative. Sheets are lightweight and easy to mat and frame. For the art in this book, I used mostly canvas sheets.

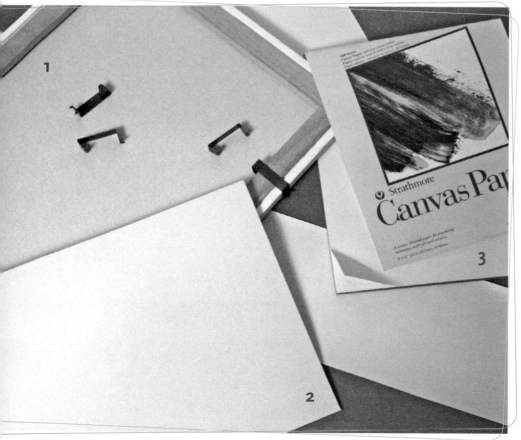

PAINTING SURFACES

Stretched canvas (1) is the most popular surface for fine art painting. It must go into a frame "as is" and is held into place with frame clips. These are metal brackets that snap over the wooden stretcher frames and grip the inside edge of the frame with sharp teeth.

Canvas panels (2) are canvas on cardboard backings. They are more rigid than stretched canvas, and the finished piece can be matted and framed.

Canvas sheets (3) can also be matted and framed. They are found in single sheets, packages and pads.

Palettes and Other Tools

Palette

I prefer a plastic palette with a lid, multiple mixing wells and a center area for mixing larger amounts of paint. Because acrylic paint is a form of plastic, dried acrylic can be peeled or soaked from a plastic palette. I find this more economical than disposable paper palettes.

However, you don't have to spend a fortune on state-of-the-art materials. Many artists make their own palettes using old dinner plates, butcher's trays or foam egg cartons. You can use your creativity to make do with what is around you.

Other Tools

The following items will make your painting experience more organized and pleasurable. None of them is expensive, and they can usually be found around the house.

Cloth rags: Keep plenty of these handy. You can use one near your palette to wipe excess paint from your brush. You can also use them to wipe excess water from your brush as you paint, which keeps your painting from getting unexpectedly watered down by a loose drip. Paper towels work too, but they can leave lint and debris.

Wet wipes: I usually have a container of wet wipes or baby wipes handy for cleaning my hands, my brushes or the floor if I drop paint.

Assorted containers: Collect jars, cans and plastic containers to use as water containers or for storing brushes.

Spray bottle of water: Use this to mist your paints to prevent them from drying out as you work.

Palette knife: This is useful for transferring acrylic paint to or from a jar as well as for mixing paint on your palette.

Masking or drafting tape: If you work with canvas sheets, you will need to tape them to a backing board as you work. Use drafting tape or easy-release masking tape to tape the edges of the sheet down. These kinds of tape will not damage or rip the sheet.

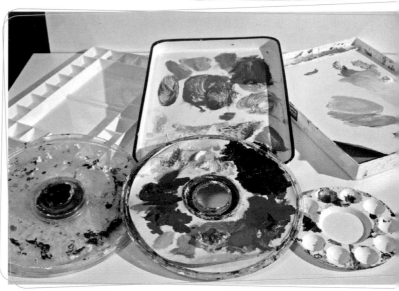

PALETTE CHOICES
Palettes come in many varieties. It is also easy to make your own with plates, egg cartons or plastic containers. Be creative!

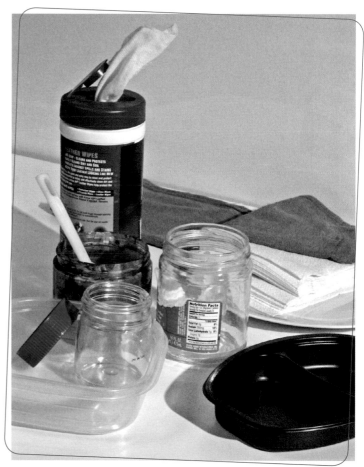

ADDITIONAL MATERIALS
Additional handy studio items, such as jars, plates, plastic trays, wet wipes and rags, can usually be found around the house.

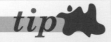

tip

Storing Leftover Paint

A palette with a lid makes it easy to preserve leftover paint. Spray a fine mist of water over the paints on your palette, then seal the lid. The extra moisture acts like a humidifier and will keep the paint from drying out for a couple of days. If you put the misted, sealed palette in the freezer, the paint will keep for weeks. It may skin over, but it will still be wet inside.

understanding color

ACRYLIC PAINTING IS A GREAT WAY to explore color theory. Its bright, rich pigments are fun to experiment with. Artists tell a lot about themselves by the colors they choose. But color is much more than just experimenting or choosing colors based on the mere fact that you "like" them. Color is scientific.

Colors react to each other, and placing certain colors together can make quite a statement. To fully understand how colors work, the color wheel is essential. You'll learn about the color wheel and some important color terms in this chapter.

Color Basics

The Color Wheel

The color wheel is an essential tool for understanding and mixing color. Having one handy can help you pick out color schemes and see how different colors affect one another. For color mixing practice, create a color wheel of your own with the paints on your palette. Here are the basic color relationships to know.

Primary Colors: The primary colors are red, yellow and blue. They are also called the "true" colors. All other colors are created from these three. Look at the color wheel and see how they form a triangle if you connect them with a line.

Secondary Colors: Each secondary color is created by mixing two primaries together. Blue and yellow make green; red and blue make violet; and red and yellow make orange.

Tertiary Colors: Tertiary colors are created by mixing a primary color with the color next to it on the color wheel. For instance, mixing red and violet produces red-violet. Mixing blue with green makes blue-green, and mixing yellow with orange gives you yellow-orange.

Complementary Colors: Any two colors opposite each other on the color wheel are called complementary colors. Red and green, for example, are complements. The painting on the facing page is an example of a complementary color scheme used in a painting. The red and green contrast beautifully, each color making the other one really stand out.

Other Color Terms to Know

Hue: Hue simply means the name of a color. Red, blue and yellow are all hues.

Intensity: Intensity means how bright or dull a color is. Cadmium Yellow, for instance, is bright and high-intensity. Mixing Cadmium Yellow with its complement, violet, creates a low-intensity version of yellow.

Temperature: Colors are either warm or cool. Warm colors are red, yellow and orange or any combination of those. When used in a painting, warm colors seem to come forward. Cool colors are blue, green and violet and all of their combinations. In a painting, cool colors will seem to recede.

Often there are warm and cool versions of the same hue. For instance, I use Cadmium Red and Alizarin Crimson. While both are in the red family, Cadmium Red is warm, with an orangey look, and Alizarin Crimson is cooler, because it leans toward the violet family.

Value: Value means the lightness or darkness of a color. Lightening a color either with white or by diluting it with water produces a tint. Deepening a color by mixing it with a darker color produces a shade. Using tints and shades together creates value contrast.

THE COLOR WHEEL
The color wheel is a valuable tool for learning color theory. Red, yellow and blue are the primary colors; orange, green and violet are the secondaries. The rest are called tertiaries.

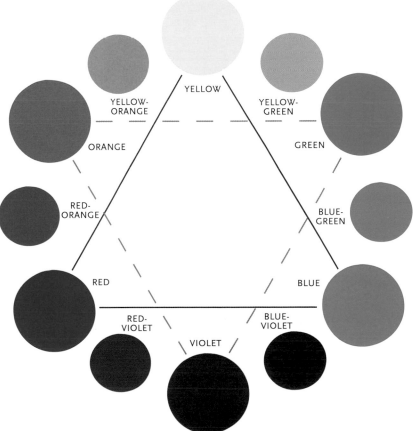

Your Basic Palette and How to Expand It

Artists love to have all of the toys associated with their craft. I am no different. I would love nothing more than a set of art supplies with a hundred different colors to choose from. But while it sounds like artistic nirvana, it really is not necessary. Color mixing is much more rewarding, educational and economical.

YOUR BASIC PALETTE
With a very small palette of only seven colors, you can create an endless array of color mixes.

| Cadmium Yellow Medium | Cadmium Red Medium | Prussian Blue | Alizarin Crimson | Burnt Umber | Ivory Black | Titanium White |

THREE PRIMARY COLORS **TWO ADDITIONAL COLORS** **TWO NEUTRAL COLORS**

TINTS
Mixing a palette color with white produces a tint.

Cad. Yellow + white = pale yellow Cad. Red + white = peachy/coral color Aliz. Crimson + white = pink Burnt Umber + white = beige Prussian Blue + white = sky blue black + white = grays

SHADES
Mixing a palette color with black produces a shade.

Cad. Yellow + black = dark olive green Cad. Red + black = maroon Aliz. Crimson + black = plum Burnt Umber + black = dark brown Prussian Blue + black = dark blue

GREENS

Greens can be difficult to mix due to the hundreds of possible variations. You can achieve green with yellow and blue, or with yellow and black. Adding brown yields an "earthy" green.

Cad. Yellow + Ivory Black = olive green olive green mix + white = grayish green Prussian Blue + Cad. Yellow = green blue/yellow mix + white = mint green

VIOLETS AND PURPLES

Shades of violet and purple can be created by mixing Cadmium Red Medium and Prussian Blue or Alizarin Crimson and Prussian Blue. Adding white to these mixes will give you shades of lavender, orchid, mauve, and so on.

Cadmium Red Medium + Prussian Blue = maroon maroon mix + white = warm gray Aliz. Crimson + Prussian Blue = plum plum mix + white = lavender

ORANGES

Cadmium Red Medium or Alizarin Crimson mixed with Cadmium Yellow will produce various shades of orange. Adding white to these colors will give you coral, peach, melon, and so on.

Cadmium Red Medium + Cadmium Yellow = orange orange mix + white = peach Alizarin Crimson + Cadmium Yellow = orange-red orange-red mix + white = coral

EARTH TONES

Earth tones can be created by adding different colors into Burnt Umber. All of these colors can be turned into a pastel by adding white. These swatches show the earth tone mix (top swatch), and what it looks like with white added (bottom swatch).

Burnt Umber + yellow Burnt Umber + red Burnt Umber + blue Burnt Umber + black

Burnt Umber + yellow + white Burnt Umber + red + white Burnt Umber + blue + white Burnt Umber + black + white

Color Schemes

The right color scheme is one that represents the subject yet also adds interest for the viewer. Experiment to achieve the exact feel you want your painting to have.

Complementary

Complementary colors, you'll recall, are colors that lie opposite each other on the color wheel (see page 17).

When complements are used near each other, they contrast with and intensify each other, as seen on this page.

When complementary colors are mixed, they gray each other down. You can use this knowledge to darken a color without killing it. When darkening a color to paint shadows, for example, you may instinctively reach for black. But black is a neutral color and will produce odd results in mixtures. Instead, darken a light color with its complement.

Yellow + violet =
pleasing shadow color

Yellow + black = green!

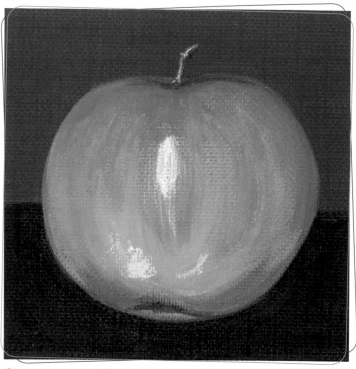

COMPLEMENTS: YELLOW AND VIOLET
A violet background intensifies the yellow of this apple, making it appear more pure and vibrant. Yellow mixed with violet makes a good shadow color for a yellow object. (Yellow mixed with black, on the other hand, makes green!)

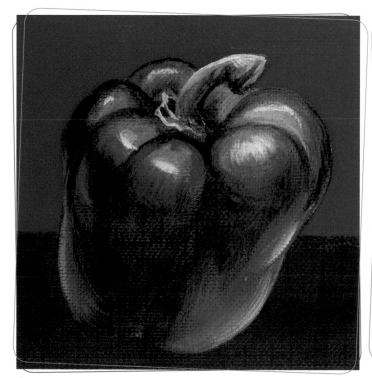

COMPLEMENTS: GREEN AND RED
A green pepper looks more vibrant on a red background. Mixing red and green produces a good color for the shadow areas.

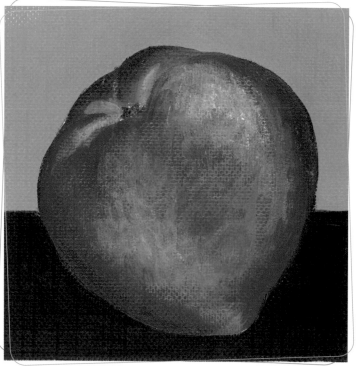

COMPLEMENTS: ORANGE AND BLUE
The orangey hue of this peach looks brighter when surrounded by blue. the shadow areas are a mixture of blue and orange.

Monochromatic

A painting created using variations of only one color is called monochromatic. This is how I often will introduce a new student to painting. A monochromatic painting can look very dramatic, like this painting of my son's dog, Kimber.

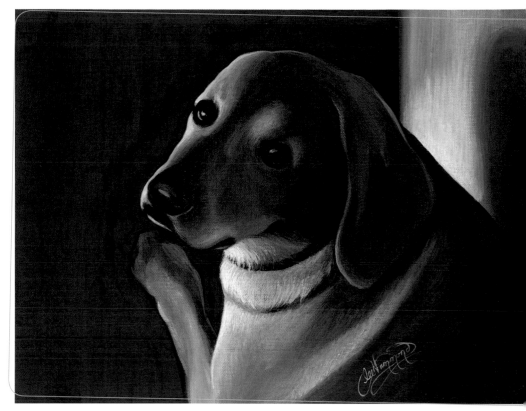

Kimber in the Moonlight
12" × 16" (30cm × 41cm)

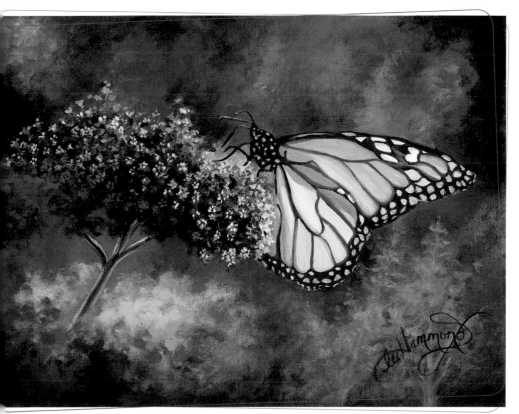

Butterfly and Lilacs
16" × 12" (41cm × 30cm)

Triadic

A triadic color scheme uses three colors that are evenly spaced around the color wheel. This example, "Butterfly and Lilacs," contains orange, purple and green. A triadic scheme always provides wonderful contrast, yet the colors are still harmonious.

basic techniques

LEARNING SOMETHING NEW IS ALWAYS A BIT
intimidating. As with anything else, the best teacher is just
plain experience—trial and error. This chapter will show you
how to grab a brush, dip it in the paint and experiment. In no
time you should feel comfortable enough to try the projects in
the book, for acrylic paint is highly forgiving. If you don't like
something, you can simply cover it up!

Try the exercises in this chapter to get a feel for flat, filbert,
round and liner brushes and how they are used. Learn the five
elements of shading and how to use them to create the illusion
of form on a flat canvas. Finally, learn the grid method of draw-
ing, which will enable you to draw any subject. You will then be
ready to move ahead to the larger projects in the book.

Exercise: Blending With a Flat Brush

Flat brushes are most commonly used for applying large areas of color and for creating blended backgrounds. I've done this blending exercise with Prussian Blue and Titanium White for a result that resembles a sky. Try it with again with different colors. Cadmium Red and Titanium White will make a tropical scene. Have fun!

My Terminology

When mixing paint, I will often use the terms "a dab" and "a touch." A dab of paint is enough to cover the entire tip of the brush. A touch is a slight amount of paint that will cover only the corner of the bristles.

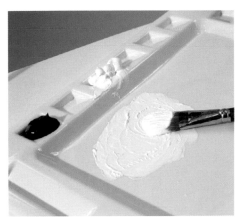

1 Take a blob of Titanium White about the size of a quarter and set it aside.

2 Add just a touch of Prussian Blue to the white. (When mixing paint, always add the darker color slowly into the lighter color; it doesn't take much to deepen a light color.)

3 Mix another blob of paint that is twice as dark as the first.

4 Dip your brush into the darker of the two blues you mixed in step 3. Hold the brush flat against the canvas and evenly distribute the paint with long sweeping strokes. Quickly go back and forth until the paint covers the canvas. You do not want to see any of the white canvas showing through the paint, so use enough to get good coverage.

5 When you have a wide stretch of dark blue, dip into the lighter blue and apply it to the canvas slightly below the first stripe using the same stroke. Quickly blend the two blues together by stroking back and forth. Try to get the paint to blend as evenly as possible. Use a clean, dry flat brush to further blend and soften. This blending takes practice, so don't get frustrated. For more experience, create a horizon line and repeat the process in reverse to make a mirror image of the sky, which will then look like a water reflection.

Exercise: Using a Filbert Brush

A filbert brush is very similar to a flat, but the tip of it is rounded, much like the shape of a tongue. That's why this brush is sometimes called a "cat's tongue."

I like to use a filbert for almost any shape that requires filling in. I find the rounded edges comfortable when going along curved edges.

A filbert brush is good for filling in areas and for going around curves. Try using your filbert to fill in a simple circle of color.

The rounded tip of the filbert brush made it much easier to paint the curved features of these subjects.

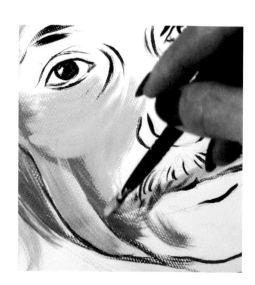

Pointed brushes such as rounds and liners are excellent for creating lines and small details. They come in a variety of sizes and are essential for painting things like trees, grass, hair and fur. They are also good for making small dots for highlights and textures. Use rounds and liners on their tips. Don't place a lot of pressure on them, because the bristles will bend over.

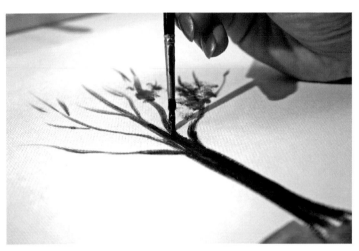

1 Paint a tree trunk with Burnt Umber and a no. 6 round. This size round brush will give you the width you need to create the trunk without repeated strokes.

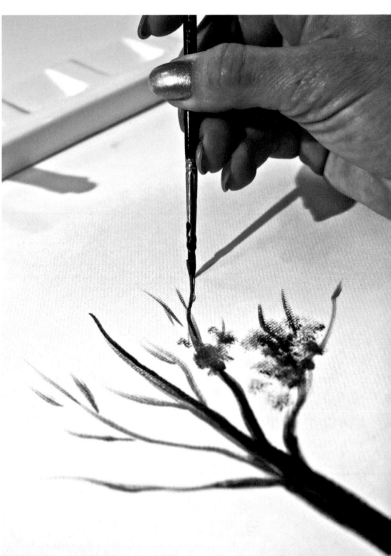

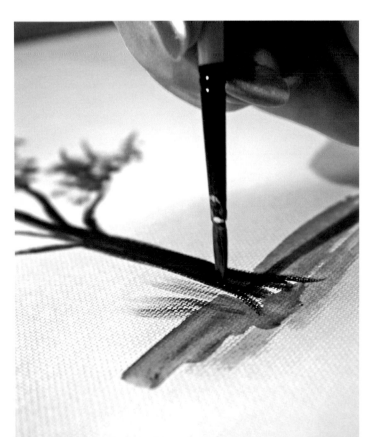

2 Switch to a no. 1 round or a liner brush to create the branches and small limbs. Add enough water to your paint to give it the consistency of thick ink. It needs to be fluid, but not transparent. After loading your brush with paint, gently pull the brush up in long strokes, lifting it slightly as you go. This will make the line taper at the end, and the limbs will get smaller and smaller, just as in nature.

3 Add many quick, short, overlapping strokes to create the illusion of layers of bark. Remember to keep your paint fluid by adding a few drops of water as you work.

Creating Texture

There are many ways to create texture with acrylic paint.

- **Drybrushing** creates a rough, textured appearance because the paint is used so sparingly that it doesn't fully cover the canvas.
- **Sponging** is great for creating textures such as distant foliage.
- **Dabbing with a liner brush** offers greater control over the placement of paint.

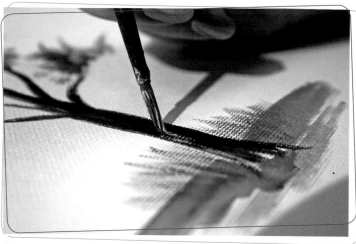

DRYBRUSHING

For this technique, use a stiff hog-bristle flat brush and unthinned paint. Dip just the ends of the bristles into full-strength paint. Wipe the brush back and forth on the palette to remove excess paint. Wipe a little more paint off with a rag. Then, scrub lightly with short strokes. Because there is barely any paint on the brush, the paint will be "hit and miss." This irregular application creates a textured appearance.

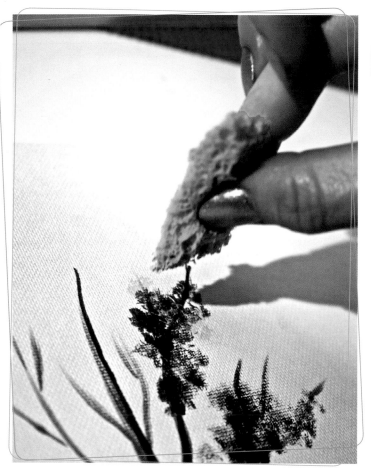

SPONGING

Tear off small pieces from a common cellulose kitchen sponge. Dip them into paint, then apply the paint with a quick dabbing motion. Use many different layers of color, from light, medium and dark, and you can make beautiful trees and landscapes.

Tearing off new pieces ensures that the edges are different every time and you won't end up with repeat patterns. A dry sponge piece will create a more distinct edge; a damp one makes a softer impression. When the paint gets dry, the sponge becomes hardened; just throw the pieces away.

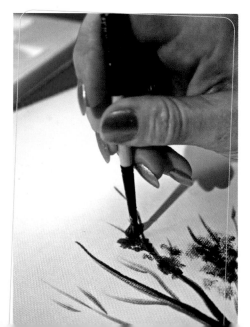

DABBING

Sometimes you need more control over the paint's application. Dabbing means making tiny spots of paint with a small liner brush. You could use this technique to create foliage, small flowers or patterns in lace.

A Closer Look

ANALYZE THIS STILL LIFE PAINTING for the techniques and brush strokes we have covered so far. Each area of the painting was created in a unique approach due to the subject's varied textures and surfaces. Some surfaces are smooth, while some are richly textured. These contrasts in textures make for very interesting paintings.

I used my entire color palette for this piece. Refer to the swatches on pages 18–19 to see how I mixed the colors.

IDENTIFYING BRUSHES AND STROKES

This painting has a lot of interesting qualities due to its range of colors and contrasting textures. Identify the type of brush used, and which type of stroke created each area.

1 Glass vase: Filbert brushes, smooth strokes.
2 Fireplace screen: Flat bristle brushes, dry-brushing.
3 Lace ribbon: Round sable brushes, dabbing technique.
4 Bricks: Filbert brushes, fill-in and dry-brush techniques.
5 Flowers: Round sable brushes, smooth fill-in technique.
6 Fern leaves: Round sable brushes, fill-in and dabbing techniques.
7 Fireplace brass: Filbert brushes, fill-in and dry-brush techniques.
8 Baby's breath: Sponging technique.

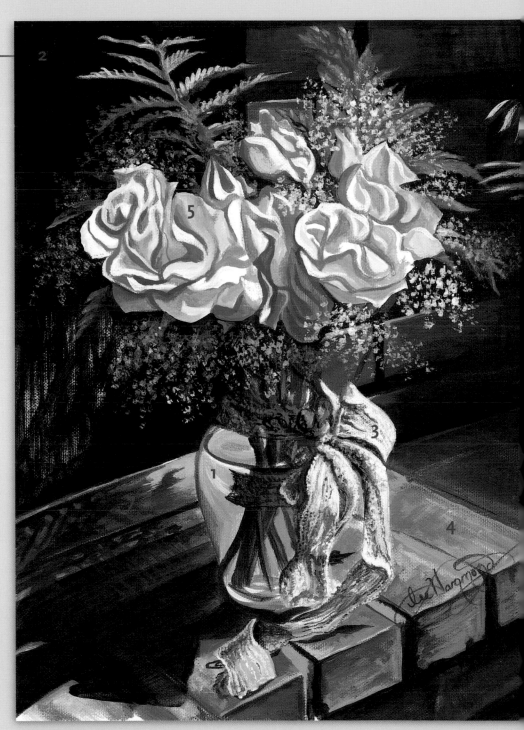

Texture Still Life
16" × 12" (41cm × 30cm)

The Five Elements of Shading

I firmly believe that the foundation for any realistic rendering, regardless of the medium, can be found in the five elements of shading on the sphere. I begin each and every book I write with this, and start every new student with this valuable lesson. If you can create a believable and realistic depiction of a sphere (for example, a ball on a table), the ability to render everything else is right at your fingertips.

When rendering a sphere, each of the five elements will correspond with a shade on a value scale. The sphere on this page has been created using a monochromatic color scheme of Burnt Umber and Titanium White. The paint swatches beneath the sphere correspond with the five elements of shading. Use these different tones as a guide.

1 **Full Light:** This is the white area, where the light source is hitting the sphere at full strength.

2 **Reflected Light:** This is a light gray. Reflected light is always found along the edge of an object and separates the dark-ness of the shadow edge from the darkness of the cast shadow.

3 **Halftone:** This is a medium gray. It's the area of the sphere that's in neither direct light nor shadow.

4 **Shadow Edge:** This dark gray is not at the very edge of the object. It is opposite the light source where the sphere curves away from you.

5 **Cast Shadow:** This is the darkest tone on your drawing. It is always opposite the light source. In the case of the sphere, it is underneath, where the sphere meets the surface. This area is void of light because, as the sphere protrudes, it blocks light and casts a shadow.

Try the example below, and commit to memory the five elements of shading. These five elements are essential to realistic painting.

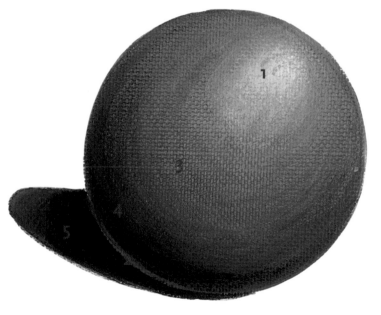

1 Full light
2 Reflected light
3 Halftone
4 Shadow edge
5 Cast shadow

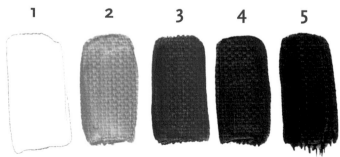

Exercise: Practice the Five Elements of Shading

Let's paint this sphere together using Ivory Black and Titanium White.

Identify where the five elements of shading (see page 28) will be, and look at the value scale shown in step 1. Look and see how the value scale with the brown tones compares with the gray tones. It is important to make the depth of tone for each box the same for both. For example, the #3 brown tones should be the same value, or darkness, as the #3 in gray. If the brown scale were copied on a black-and-white photocopier, it would look the same as the scale on this page.

MATERIALS LIST

Paints
 Ivory Black
 Titanium White
Brushes
 no. 4 sable or synthetic round
 no. 6 sable or synthetic filbert
Other
 mechanical pencil
 ruler

1 2 3 4 5

1 Mix Your Colors

Value #5 is pure Ivory Black. Mix a very small amount of Titanium White with Ivory Black until you match the #4 dark gray. When you are happy with your color, take some of the dark gray, and mix a little more Titanium White into that to create the #3 halftone. Add some more white to that to create the #2 light gray. Value #1 is pure Titanium White.

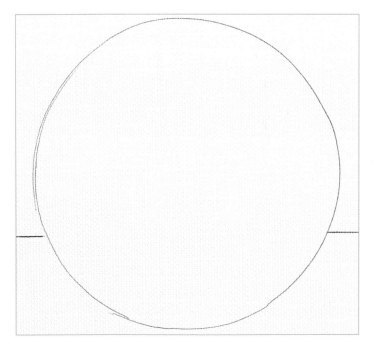

2 Draw the Circle

With a mechanical pencil, trace a perfect circle onto your canvas paper. With a ruler, create a border box around the sphere, then draw a horizontal line behind the sphere. This will represent a table top, and give the illusion of a background area.

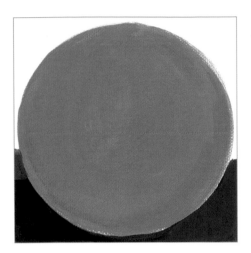

3 Paint the Base Colors

With a dark gray that matches the #4 on your value scale, base in the table top with a no. 4 round brush. This brush is pointy and can get into the corner, and go around the curved surface easily. This deep gray will give us a foundation to build the rest of the painting on.

To paint the sphere, begin with the darkest area first. In this case, it is under the sphere in the cast shadow. Use the Ivory Black full strength (#5 on the value scale) to create the cast shadow over the dark gray. Use the same no. 4 round brush.

Switch to the no. 6 soft filbert brush, and fill in the entire sphere with a medium gray mixture. This should match the #3 on the value scale. Be sure to completely fill in the sphere so that there is no canvas showing through.

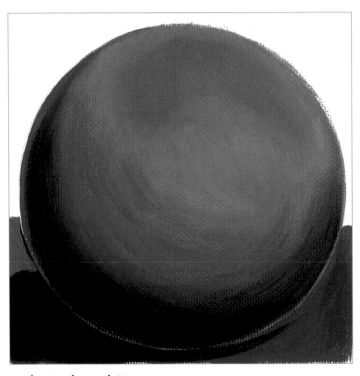

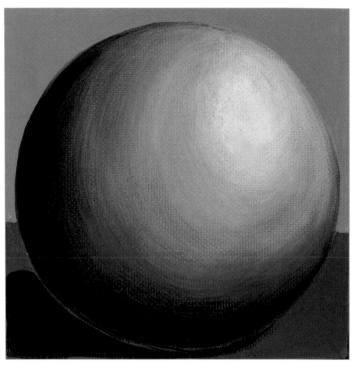

4 The Awkward Stage

With the #4 dark gray mixture, apply the shadow edge of the sphere with a no. 6 soft filbert brush while the medium gray paint is still wet. The filbert brush will blend the tones together. Make sure the shadow is parallel to the edge of the sphere, allowing the two colors to blend. Allow the dark gray to show along the edge of the sphere, creating the reflected light.

While the paint is still wet, add some of the medium gray mixture above the dark gray, and blend the two together using long rounded strokes that follow the contours of the sphere to create the halftone area. Blend until the tonal transitions are smooth.

5 Finish

With Titanium White, apply the full light area and blend it into the halftone using a no. 6 filbert. To make the light areas stand out, apply some of the medium gray mixture behind the sphere to create the background. The light edge of the sphere contrasts against it.

This is not as easy as it looks, so please do not get frustrated. Remember, you can go over things as many times as you want. I often will add some paint, and softly reblend into the paint that is already there. I can spend a lot of time trying to get it just right. This is all part of the challenge!

Create Spheres Using Complementary Colors

Practice painting the monochromatic sphere from the previous exercise. It really is the foundation for everything else you'll paint. When you feel you've got it, try painting spheres in color.

Remember the five values you created on page 29? For spheres in color, the main color of your sphere is a 3 on the value scale. Mix the lighter values (1 and 2) by adding Titanium White. Mix the darker values (4 and 5) by adding the complement of the main color. As you learned on page 20, complements produce a pleasing grayed-down color, perfect for painting shadows.

Use Color Complements

Complementary colors are colors opposite each other on the color wheel (see page 17). Using complementary colors will help intensify the colors in your painting. For more on complements, see chapter two, page 20.

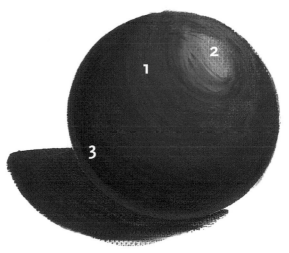

1 Cadmium Red Medium
2 Cadmium Red Medium mixed with Titanium White
3 Cadmium Red Medium mixed with green (Prussian Blue + Cadmium Yellow Medium)

1 Green (Prussian Blue + Cadmium Yellow Medium)
2 Green mixed with Titanium White
3 Green mixed with Cadmium Red Medium

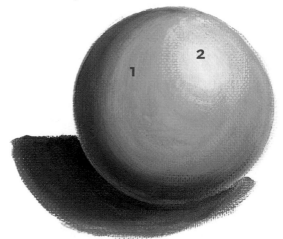

1 Cadmium Yellow Medium
2 Cadmium Yellow Medium mixed with Titanium White
3 Cadmium Yellow Medium mixed with Violet (Alizarin Crimson + Prussian Blue)

1 Prussian Blue
2 Prussian Blue mixed with Titanium White
3 Prussian Blue mixed with orange (Cadmium Yellow Medium + Cadmium Red Medium)

Exercise: Paint Reflections

It is easy to see, when looking at these grapes, that the five elements of shading played an important part in creating them. While the grapes closely resemble a sphere, the reflections are much more extreme and will vary from one grape to another. This looks more complex but is much easier to paint than the overly controlled surface of the spheres. The highlights here do not blend out and disappear into the other tones. Here, they are stark and can be created with a swipe of the brush.

MATERIALS LIST

Paints
- Cadmium Red Medium
- Cadmium Yellow Medium
- Ivory Black
- Prussian Blue
- Titanium White

Brushes
- no. 4 sable or synthetic round
- no. 2/0 sable or synthetic liner

Other
- mechanical pencil

 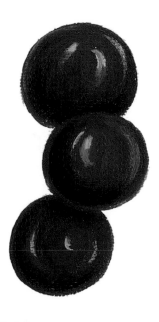

1 Paint the Base Colors
Begin by lightly drawing three stacked circles with your mechanical pencil. Fill in each one with Cadmium Red Medium using a no. 4 round brush.

2 The Awkward Stage
Mix a touch of Ivory Black into the Cadmium Red Medium paint to create a dark red mixture. Apply the "shadow edge" to each grape using a small round brush. Be sure to leave reflected light around the edges. Blend and soften the tones by brushing the darker color into red. With the darker color, be sure to create a shadow where one grape overlaps another.

3 Finish
Using a small pointed brush, such as a no. 2/0 liner, add the shiny look to the grapes with light highlights of Titanium White paint. Use brushstrokes that follow the round contours of the circle.

4 Create a Bunch!

Have even more fun by creating the whole bunch of grapes. Simply sketch in the circles, and repeat the previous process over and over.

To create the leaves, mix Prussian Blue and Cadmium Yellow Medium together to make green. With a round brush, fill in the leaves with this mixture. Feel free to make your leaves lighter than mine if you'd like. This is a time for you to experiment and have fun.

Mix some Ivory Black into the green mixture to create the veining. Use the no. 2/0 liner brush to create the delicate lines. For the highlight areas, add some white into the green mix.

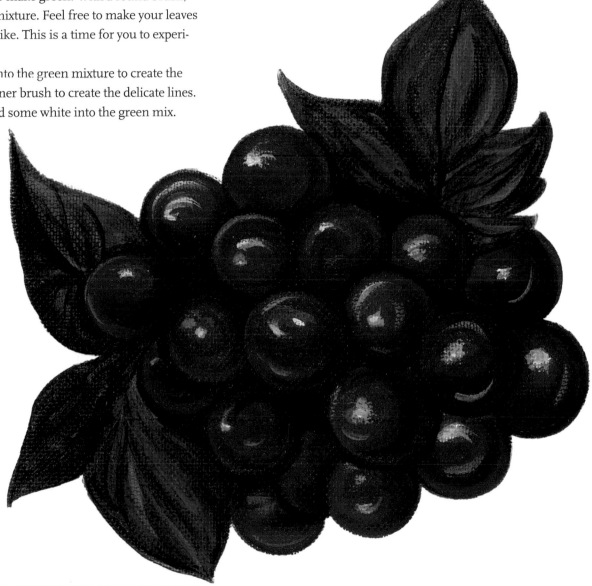

tip

Use Contrast to Create Depth

I always find it so amazing how much color and depth can be created with so few colors. Deep shadows and bright highlights make this possible. The extreme contrast between them creates an illusion of shine, which I find very beautiful.

Exercise: Paint Shadows and Highlights

The grapes on the previous page had very few colors in their creation. Although this apple is less complex in its shape when compared to the grapes (we are dealing with one continuous surface instead of many overlapping ones), the color is more complicated. Not only do we have variegated color, we also have the extreme lighting situation to replicate. All of the colors of the apple are affected by intense shadows and bright highlights.

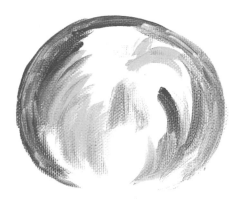

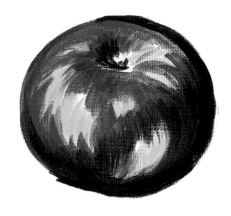

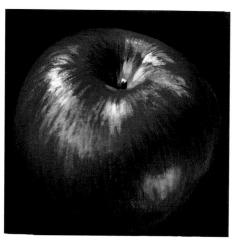

1 Draw, Then Paint the Base Colors

When I paint, I always create my paintings with layers. The first layer of paint is often very light and transparent. I use this first layer as a road map and color guide on which to build.

In the first stage of painting this apple, start with a light pencil outline first. Apply Cadmium Red Medium and Cadmium Yellow Medium with diluted, transparent layers using curved brushstrokes for form.

2 The Awkward Stage

Build up color with thicker applications of paint using curved strokes to maintain roundness. Add Alizarin Crimson into the red for more depth of color. Place some Ivory Black around the edges of the apple to begin the background. Streak the black into the surface of the apple to create a shadow edge. At this stage the colors will start to mix into one another.

3 Finish

To finish this piece, continue adding layers of paint with the curved strokes, allowing the colors to blend together somewhat. Look closely, and you can see where a brownish hue has been created in areas by the red, yellow and black mixing together. You can also see a touch of green where the yellow and black blended together.

Add some Titanium White highlights to the upper portion of the apple and tip of the apple stem. Draw a square around the apple with a ruler, and fill in the background with black.

Look at the painting of the fruit bowl on page 6. You can see how I painted the apple in that piece the very same way.

This simple project in a brown monochromatic color scheme will give you some practice going outside the continuous circle of the sphere. You can see how adding the neck to the pot changes the shape and the affects of the five elements of shading. Compare this to the sphere on page 28.

Compare this to the sphere on page 28.

MATERIALS LIST

Paints
Burnt Umber
Titanium White
Brushes
no. 4 sable round
Other
mechanical pencil

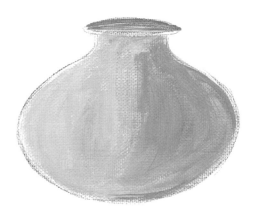

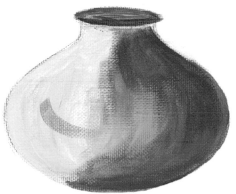

1 Draw the Pot
Lightly sketch the pot's outline with a mechanical pencil. Be sure it is symmetrical. Lightly fill in the area with a transparent mix of Burnt Umber and Titanium White plus a touch of water.

2 The Awkward Stage
Create the dark side of the pot with Burnt Umber. Follow the contours with curved brush strokes. Fill the inner rim of the neck as well.

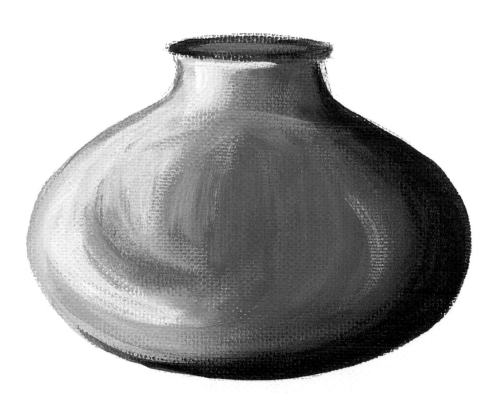

3 Finish
Add Titanium White to the Burnt Umber, and continue to develop the shape of the pot. You can see how I literally "draw" with paint. My brush-strokes create the form with their direction.

Basic Drawing

Why Drawing Is Important

To be a good painter, it is essential to learn some basic drawing skills. All paintings must have a firm foundation to build on, and the shapes of the objects you are painting must be accurate.

I take my own photo references to use in creating my artwork. To accurately depict what I want to paint, it is important to draw the shapes accurately in the beginning, before I start to paint.

How the Grid Method Works

When I teach drawing to my students, I introduce them to the grid method of capturing shapes. It is an excellent method for breaking down a complex subject into smaller, more manageable shapes.

1. **Place a grid of squares over a photo reference.** One-inch squares usually work well. If you have many small details to capture, you can place smaller squares over your photo. This will break the subject matter down into more manageable pieces.

2. **Draw an identical grid on your canvas.** The squares can be the same size, larger or smaller, but the grid on your canvas must have the same number of rows and columns as the one on the reference photo.

3. **Lightly draw what you see within each square.** This makes it easy to get the shapes right.

When using this approach, remember this important key: Everything you draw or paint should be viewed as a puzzle. And all of the pieces of the puzzle are nothing more than patterns of interlocking shapes of light and dark.

1	2	3	4	5	6	7	8	9	10	11	12	13
14	15	16	17	18	19	20	21	22	23	24	25	26
27	28	29	30	31	32	33	34	35	36	37	38	39
40	41	42	43	44	45	46	47	48	49	50	51	52
53	54	55	56	57	58	59	60	61	62	63	64	65
66	67	68	69	70	71	72	73	74	75	76	77	78
79	80	81	82	83	84	85	86	87	88	89	90	91
92	93	94	95	96	97	98	99	100	101	102	103	104
105	106	107	108	109	110	111	112	113	114	115	116	117
118	119	120	121	122	123	124	125	126	127	128	129	130
131	132	133	134	135	136	137	138	139	140	141	142	143
144	145	146	147	148	149	150	151	152	153	154	155	156
157	158	159	160	161	162	163	164	165	166	167	168	169
170	171	172	173	174	175	176	177	178	179	180	181	182
183	184	185	186	187	188	189	190	191	192	193	194	195
196	197	198	199	200	201	202	203	204	205	206	207	208
209	210	211	212	213	214	215	216	217	218	219	220	221
222	223	224	225	226	227	228	229	230	231	232	233	234
235	236	237	238	239	240							

THE GRID METHOD OF DRAWING

I have acetate overlays with the grid on them made at the copy shop. It is then easy to take whatever size grid you need and tape it over any photo you want to paint. You can even number the individual boxes to help you keep track as you draw.

Exercise: Practice the Grid Method

Let's practice using the grid method. The shapes of these wine glasses are fairly simple to draw when using the grid method. You can use regular paper for this exercise.

The canvas paper I used for this book is wonderful for the grid method, because pencil lines lift up and are easy to erase with a kneaded eraser. It becomes more of a challenge on stretched canvas, because of the rougher surface. Stretched canvas, while still erasable in small doses, really holds the graphite and will smear. For stretched canvas, I would suggest using a projector (see the tip below) to get your outline, so you don't have to remove grid lines when you are ready to paint.

For more practice with the grid method, go through the book and practice creating the line drawings of the projects you would like to try. Use regular paper at first, just to get the hang of the method. When you are comfortable with your ability to draw and want to start painting, switch to canvas paper.

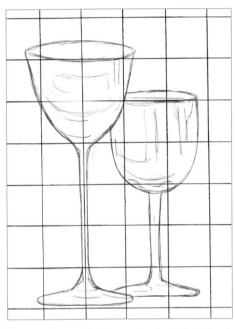

1 Study the graphed example. Really look hard and try to see everything as interlocking nonsense shapes within each square.

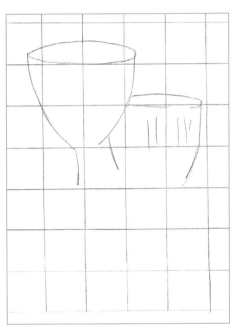

2 Lightly apply a grid of one-inch squares to your paper with a mechanical pencil. Using the grid as your guide, begin drawing the shapes of the wine glasses on the canvas paper, one box at a time. Go slowly, concentrate on one square at a time, and forget you are drawing a glass.

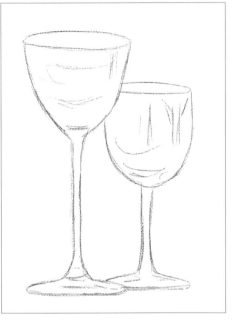

3 When you have accurately drawn the shape of the glasses, erase the grid with a kneaded eraser, and leave just the outline.

Using a Projector

If you don't want to erase grid lines, you can use an art projector to shine an image of a reference photo onto your canvas. Adjust the projector until the image fills the canvas the way you want it to, then trace the image lightly onto the canvas with a pencil. Art projectors are available wherever art and craft supplies are sold.

still lifes

IT'S TIME TO DO OUR FIRST FINISHED PAINTINGS! This chapter starts off with a simple subject: wine glasses. Don't let the fact that they are made of glass scare you. It is actually no harder to paint shiny and transparent things than it is to paint apples or grapes. Painting reflections is merely a matter of viewing them as patterns of color. If you have the five elements of shading in the back of your mind as you paint (see page 28) and an accurate line drawing, your are well on your way to great painting.

Continue through all the painting demonstrations in this chapter and learn how to use shading, backgrounds and color relationships to paint any still life subject.

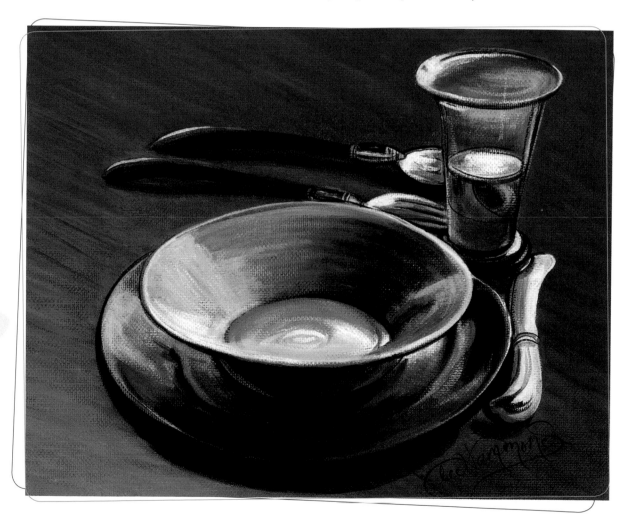

Exercise: Paint Glass and Shine

I selected these wine glasses for this exercise because the five elements of shading—cast shadow, shadow edge, halftone, reflected light and full light—are easy to pick out.

MATERIALS LIST

Paints
- Ivory Black
- Prussian Blue
- Titanium White

Brushes
- no. 2/0 liner brush
- no. 3 sable or synthetic filbert

Other
- mechanical pencil
- ruler
- kneaded eraser

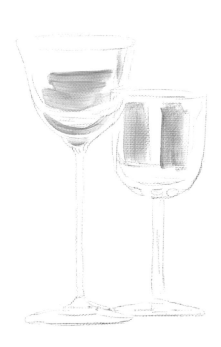

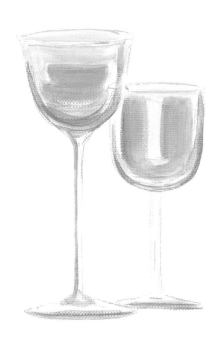

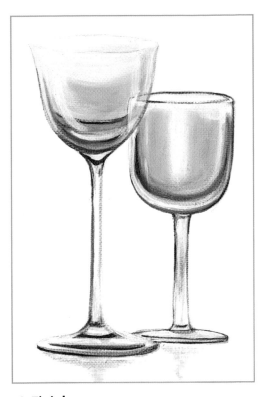

1 Sketch and Paint the First Strokes

Sketch the wine glasses on your canvas using the grid method. With a diluted mixture of Prussian Blue and a small no. 3 sable or synthetic filbert brush, apply some streaks of paint where the shadow edge of the glass is. This begins the process of creating roundness.

2 The Awkward Stage

Use a no. 2/0 liner brush to paint the small stems of the glasses using the diluted Prussian Blue from step 1. Now mix a small amount of Titanium White into the Prussian Blue to make it more opaque. With the filbert brush, continue blocking in the colors. Can you see how it is covering the canvas more? At this stage you are creating "patterns" of dark and light.

3 Finish

To deepen the shadow areas, mix some Ivory Black into the Prussian Blue and white to create a dark blue-gray. With a liner brush, add the blue-gray mixture to the shadow edges. The roundness of the glasses really jumps out now.

To make the glasses look transparent and shiny, take pure white into the highlight areas. Paint right over the existing painting, which makes the white look like it is reflecting off of the outer surface of the glass. You are painting blotches and patterns of color, which go together to create the illusion of glass.

GLASS AND METAL

The wine glasses were a simple project because of the simple color scheme and the white background. Now let's try something a bit more complicated. This project brings in two new elements: a dark background and the use of color.

MATERIALS LIST

Paints
- Burnt Umber
- Cadmium Red Medium
- Cadmium Yellow Medium
- Ivory Black
- Titanium White

Brushes
- no. 4 sable or synthetic filbert
- no. 2 sable or synthetic round
- no. 1 liner brush

Canvas or Canvas Paper
- 9" × 7" (23cm × 18cm)

Other
- mechanical pencil
- kneaded eraser

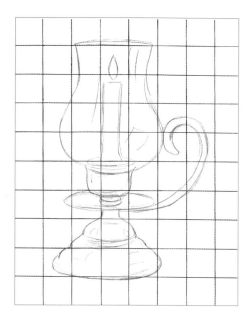

1 Do the Drawing

Use this grid to create an accurate line drawing of your own. Lightly draw a grid of one-inch squares on your canvas paper and then draw what you see one box at a time. When you are sure the drawing is accurate, remove the grid with a kneaded eraser, leaving just the outline of the candle holder.

2 Paint the Candle and Start the Background

Look at the candle. The five elements of shading are there. The stripes of light and dark create the look of a cylinder. The placement of the lights and darks makes it look rounded. To paint it, mix a touch of Cadmium Yellow Medium with Titanium White, then add a touch of Burnt Umber. This makes a dark yellow ochre color. In addition, create a light and a medium version of this color by pulling aside portions of the mix and adding white.

Create the candle with vertical brushstrokes and a filbert brush. Start with the lightest color mixture first, and then blend the darker colors into it. The patterns are important in creating the look of a cylinder. Save some of this yellow for step 3.

Start to fill in the background with Ivory Black. The dark background will create the light edges of the subject.

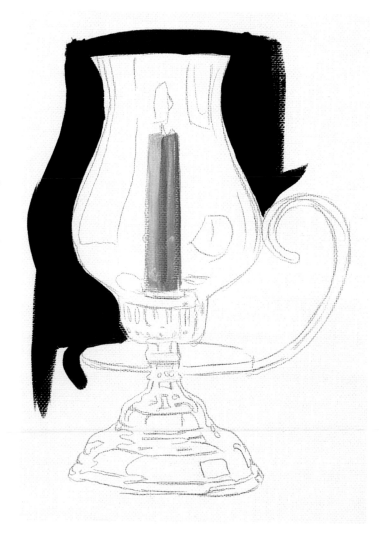

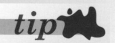

Let the Darks Create the Lights

Rather than outlining objects, let dark colors create the edges for light areas. In this painting, we can create the light outside edges of the candle holder by filling in the black background around it.

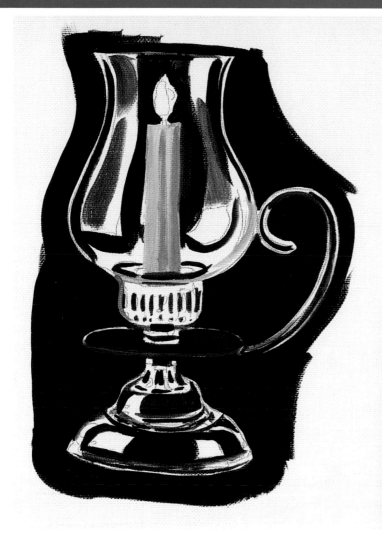

3 The Awkward Stage

Finish filling in the background to create all of the outside edges. Fill in some of the smaller black areas inside of the candle holder. Look at these areas objectively as small shapes, and assign each one a color. Any subject is easier to replicate if you think of it as puzzle pieces.

Mix a gray using black and white and apply it with a no. 2 round to the light areas of the glass. Add some of the yellow from step 2 into the lower right side of the glass. This is where the color of the candle is reflected in the glass.

Add a touch of Cadmium Red Medium to Burnt Umber. Look at the areas where I used this warm brown tone, and apply to your painting accordingly with a small liner brush.

4 Finish

To finish the painting, continue filling in areas with patterns of color using a no. 2 round. Add Cadmium Yellow Medium to some areas to create the look of gold-colored metal.

To make the glass look real, mix some white and yellow together and drybrush it into the glass with curved brushstrokes to create reflections. Just as in the wine glass exercise on page 39, the highlights curve to create the roundness of the glass.

To make the candle flame, mix an orange out of Cadmium Yellow Medium and Cadmium Red Medium. It is the perfect finishing touch.

Candle Holder
9" × 7" (23cm × 18cm)

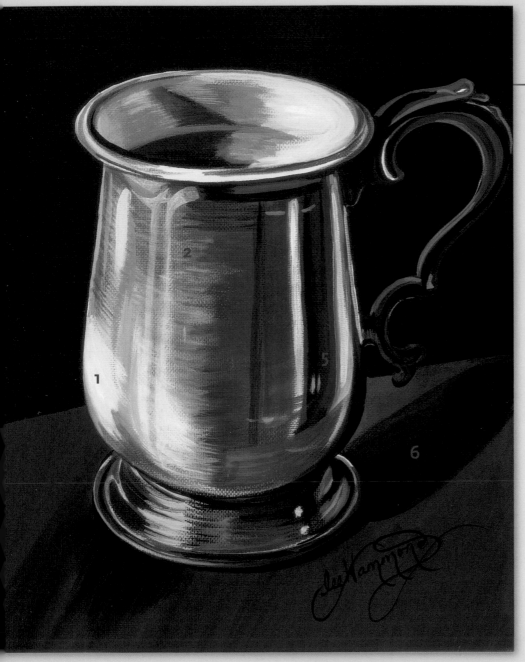

THIS PEWTER MUG WAS PAINTED
using all of the same colors we used for
the glass candle holder in the previous
demonstration. You can see how reflec-
tions on pewter are painted the same way
as reflections on glass.

Again, the five elements of shad-
ing (see page 28) were used to make the
mug look rounded. The reflections were
applied vertically but curved following
the mug's rounded contours. I created
the look of brushed pewter by taking
some white and drybrushing the texture
in a horizontal stroke across the paint I
had already applied.

Compare the mug to the candle
holder on the previous page. You can see
all of the same colors. The handles are
almost identical in the way that they were
painted.

Pewter Mug
11½" × 9½" (29cm × 24cm)

1 Full light
2 Dry-brushing for pewter look
3 Halftone
4 Reflected light
5 Shadow edge
6 Cast shadow

CUT GLASS

I selected this decanter for its beautiful patterns and texture. It may seem a bit daunting at first with all of the delicate details, but subjects like this are actually easier than you might think. The object is made up of geometric patterns that go together much like pieces of a puzzle. I like working in just black and white. It gives a dramatic look and helps illustrate the extreme shine of the crystal.

MATERIALS LIST

Paints
Ivory Black
Titanium White

Brushes
no. 3 sable or synthetic filbert
no. 2 sable or synthetic round
no. 2 sable or synthetic liner

Canvas or Canvas Paper
16" × 12" (41cm × 30cm)

Other
mechanical pencil
kneaded eraser

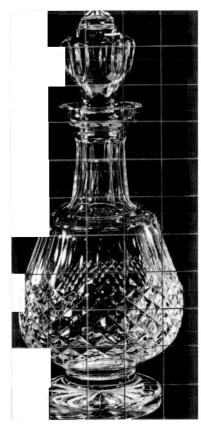

A GRAPHED PHOTO
This graphed photo will help you draw the decanter and all of the small shapes and patterns.

1 Draw the Decanter

Lightly draw a grid of one-inch squares on your canvas paper, and then draw what you see in the graphed photo (at left), one box at a time. When you are sure the drawing is accurate, remove the grid with a kneaded eraser, leaving just the outline. Now you are ready to paint!

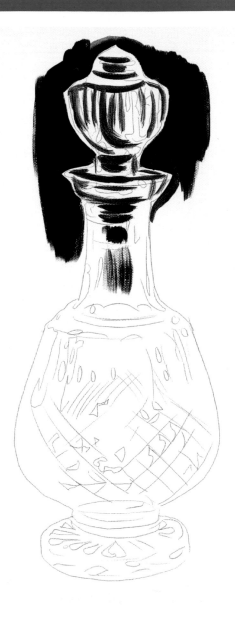

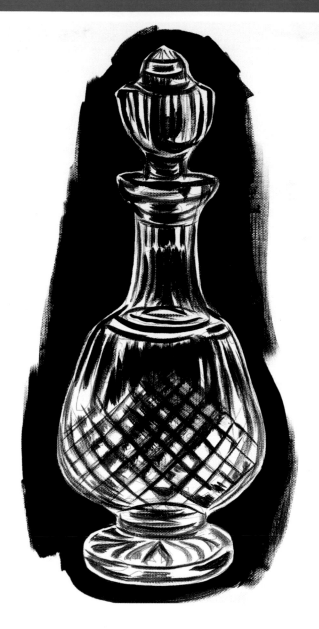

2 Start the Background

With pure Ivory Black and a no. 3 sable or synthetic filbert brush, apply paint around the edge of the decanter and into the background. With a no. 2 round brush, add some dark strokes into the glass to begin the patterns.

3 The Awkward Stage

Finish painting the background so that the sides of the decanter are fully described. Continue blocking in the details of the glass. At this stage you are merely creating "patterns" of dark and light. Look at the photo reference on page 43 for proper placement of the pattern pieces. However, do not be upset if you don't capture every minute detail; the illusion of cut crystal will still come through.

At this stage I have used only Ivory Black. The white you see here is just the white of the canvas.

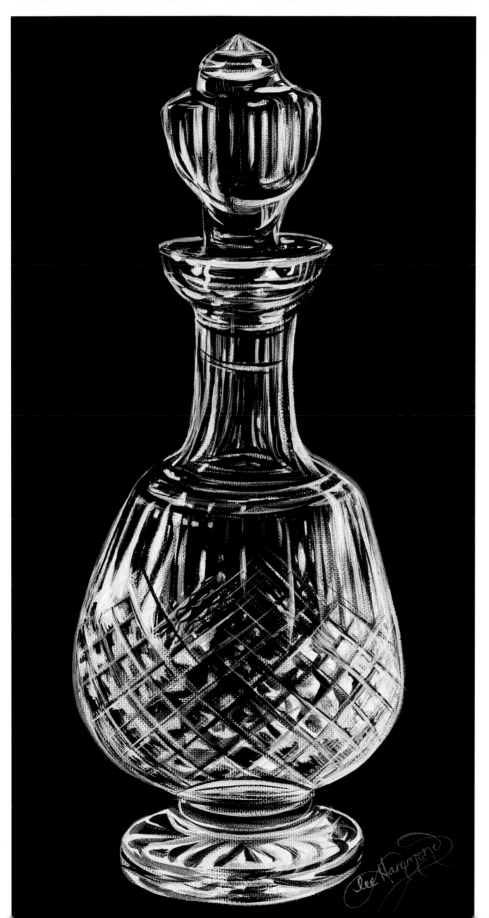

4 Finish

Continue developing the dark patterns. These patterns help create the illusion of roundness and form, so follow the curves of the decanter. With a no. 2 liner brush, add some Titanium White on top of the black lines that define the glass's pattern. Be careful to follow the contours of the patterns as they go around the glass. Can you see how the curves of the patterns create the form? The roundness of the glass is now very obvious.

Place more pure white into the highlight areas.

Notice that you have not painted "transparently" to make glass. You painted patterns of light and dark that went together to create the illusion of glass.

Crystal Decanter
16" × 12" (41cm × 30cm)

PAINT A MONOCHROMATIC SCENE

As with the glass patterns in the decanter on page 43, it is not important to be overly accurate with the area of the plant in this painting. It is just a conglomeration of light and dark shapes that creates the illusion of plant life. This painting is not as black and white as the one before; it uses more gray tones to capture the scene.

MATERIALS LIST

Paints
 Ivory Black
 Titanium White

Brushes
 no. 4 sable or synthetic filbert
 no. 2 sable or synthetic round
 no. 2 sable or synthetic liner

Canvas or Canvas Paper
 14" × 11" (36cm × 28cm)

Other
 mechanical pencil
 kneaded eraser

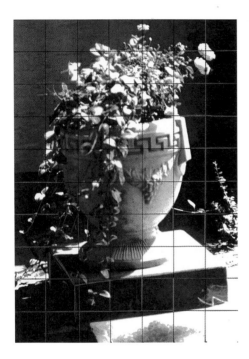

A GRAPHED PHOTO
Use this graphed photograph to create an accurate line drawing of the patio flower pot.

1 Draw the Subject

Lightly draw a grid of one-inch squares on your canvas paper, and then draw what you see one box at a time. Much of this a mishmash of shapes, so just get the important ones. It will really come together when you start to paint. When you are sure you have enough information, remove the grid with a kneaded eraser, leaving just the outline.

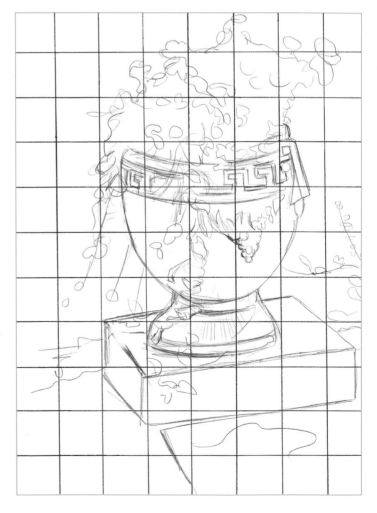

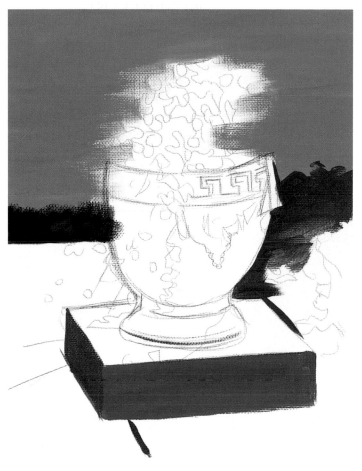

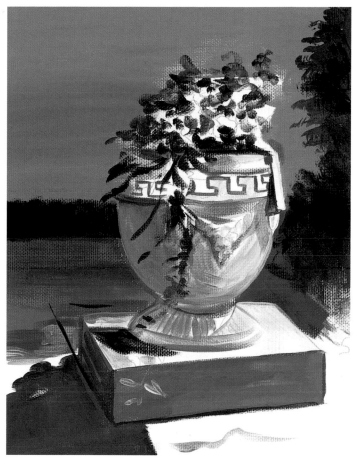

2 Start the Shadows and Background

Create a medium gray with Ivory Black and Titanium White and apply it to the background with a no. 4 filbert brush. Let the background gray extend into the area where the plants will go later.

Add a bit more Ivory Black to the mixture, creating a darker gray, and paint in the base of the concrete stand. With pure Ivory Black, paint in the strip of darkness along the horizon line.

3 The Awkward Stage

Continue to "block in" the patterns with the no. 4 filbert, striving for smooth and even coverage. The background, the foreground and the pot are all various shades of gray, from light tones to dark. The flowerpot has a round surface, so look for the light source and remember the five elements of shading when painting it.

Paint the foliage on the right side with Ivory Black and a no. 2 round brush, painting right over the background.

Also with the no. 2 round and Ivory Black, paint the beginning of the patterns that represent the plants in the pot. It is just an illusion created by blobs of paint, so paint freely, concentrating on the overall shape you are trying to make, not on the placement of every little leaf and detail.

Everything at this stage of the painting is just blocked in for shape and tone.

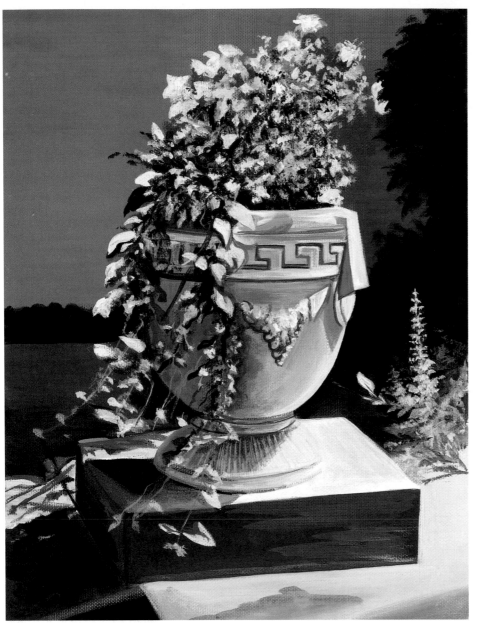

4 Finish

The final touches of the painting can take a while, but as you can see, it is worth the effort. With Titanium White and the no. 2 liner brush, create the small details and the highlights. These bright areas add a new dimension of depth to the painting and really capture the light source of the outer surfaces. The full light can clearly be seen on the right side of the planter and on the leaves.

Monochromatic Flower Study
14" × 11" (36cm × 28cm)

PEACHES AND TEAPOT

I like to play colors off each other. In this piece, the colors of the peaches enhance the color of the teapot. This is because red and green are opposites on the color wheel (see page 17), and placing them side by side always creates a good color contrast. You can see another complementary color scheme in use here as well. The colors blue and orange are opposites, so the sky color helps illuminate the orange colors of the peaches and the orange colors reflected on the tabletop.

This is a good project for practicing your strokework. This painting was mostly done with the no. 3 filbert brush, and long "fill in" strokes. When painting in long strokes, it is important to follow the contours of the object you are painting. In this example, curved strokes create the roundness of the teapot, straight strokes create the flat surface of the table, and horizontal strokes give the illusion of a sky in the background.

MATERIALS LIST

Paints

 Burnt Umber
 Cadmium Red Medium
 Cadmium Yellow Medium
 Ivory Black
 Prussian Blue
 Titanium White

Brushes

 no. 3 sable or synthetic filbert
 no. 2 sable or synthetic liner
 no. 2 sable or synthetic round

Canvas or Canvas Paper

 16" × 12" (41cm × 30cm)

Other

 mechanical pencil
 kneaded eraser

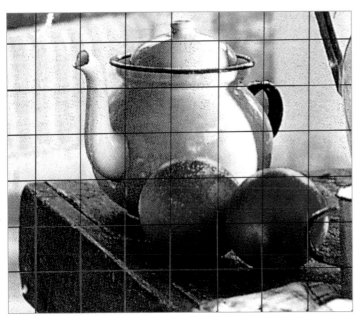

A GRAPHED PHOTO
The graph will help you draw this still life scene.

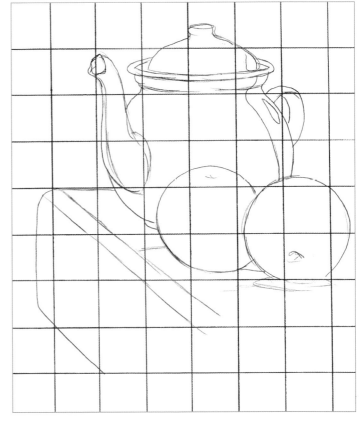

1 Draw the Still Life

Create an accurate line drawing on your canvas paper using the grid method. When you are satisfied with your drawing, erase the grid lines.

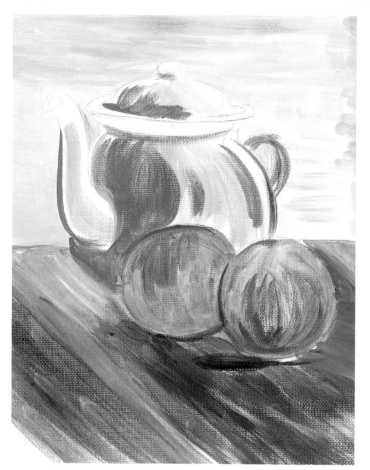

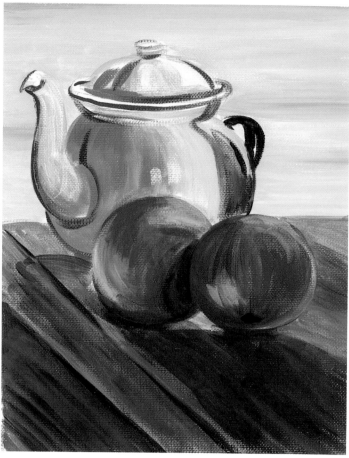

2 Block In the Colors

Block in the colors of the painting, using a no. 2 round for smaller areas such as the teapot's spout and handle and a no. 3 filbert for large, open areas. Pay attention to the direction of your brushstrokes: Let them follow the contours of the objects to begin creating their forms.

With the no. 3 filbert and a mixture of Prussian Blue and Titanium White, paint the sky with horizontal strokes. Save some of this color on your palette; it will be reflected into the teapot and the tabletop later on.

Paint the peaches with a mixture of Cadmium Red Medium and Cadmium Yellow Medium. Add a touch of Burnt Umber into the Cadmium Red Medium for the shadow areas.

Mix a jade green with Titanium White, Cadmium Yellow Medium, Prussian Blue and a touch of Ivory Black to gray it. Use this to paint the teapot. Save this color on your palette.

Paint the brown table with a mix of Burnt Umber, Cadmium Red Medium and Cadmium Yellow Medium.

3 The Awkward Stage

For this step, use the same colors, but apply them more heavily for more coverage. Again, the brushstrokes in this piece are very important for creating the forms, especially those of the teapot and the peaches. To create the fine lines seen on the edge of the teapot and its lid, use a no. 2 liner brush for more precision. Use Ivory Black for contrast, especially in the handle.

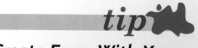

Create Form With Your Brushstrokes

Make sure your brushstrokes always follow the contours of the surface you are painting.

tip

For a Finished Look, Completely Cover the Canvas

Compare the final painting to step 3, and you can really see the difference it makes when you take the time to completely cover the canvas and smooth out the shading and edges. This extra care is what takes a painting from "the awkward stage" to a finished work of art!

4 Finish

Using the no. 2 liner brush and the same colors as in the previous step, smooth out the textures and clean up the edges. Make sure the paint completely covers the canvas. Use some Titanium White to add a few highlights on the rim and belly of the pot.

Peaches and Teapot
16" × 12" (41cm × 30cm)

Unify a Painting With Color

This is a wonderful painting using earth tones. The brownish hues give it a natural feel, and gray tones give the illusion of real ceramic. Look around the painting, and you will see the brown tones reflected into every surface. This reflecting and distributing of light is essential to a good painting. Tying in the colors of your subject with its environment makes a painting look more realistic.

MATERIALS LIST

Paints
- Burnt Umber
- Cadmium Red Medium
- Cadmium Yellow Medium
- Ivory Black
- Prussian Blue
- Titanium White

Brushes
- no. 4 sable or synthetic flat
- no. 2 sable or synthetic round
- no. 2 sable or synthetic liner

Canvas or Canvas Paper
- 8" × 10" (20cm × 25cm)

Other
- mechanical pencil
- kneaded eraser

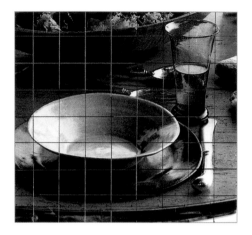

A Graphed Photo
Use the graphed photo to achieve your foundation shapes on the canvas.

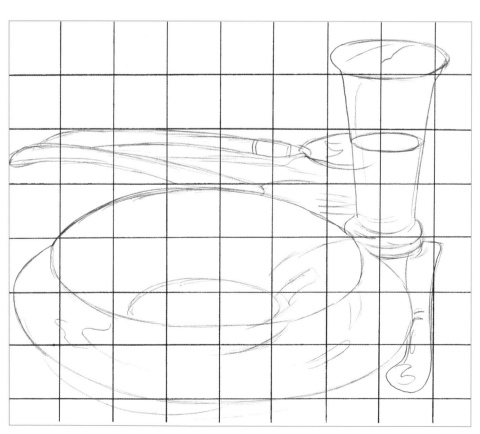

1 Draw the Subject

Use the graphed photo at left to create an accurate line drawing on your canvas paper. Remove the grid lines on your canvas when you are happy with your drawing. This is a fairly simple subject to sketch.

2 Paint the Foundation Color

Well, this certainly doesn't look like much, but it is an important first layer. Mix Burnt Umber, Cadmium Red Medium and a touch of Cadmium Yellow Medium, dilute it with some water, and streak this in using a no. 4 flat brush. Use diagonal brushstrokes to start indicating the wood grain of the tabletop. Let your brushstrokes extend into the areas where the bowl and other objects will be painted. This assures good coverage in the background. When you paint the objects in the next step, you won't have to worry about gaps between the objects' edges and the background.

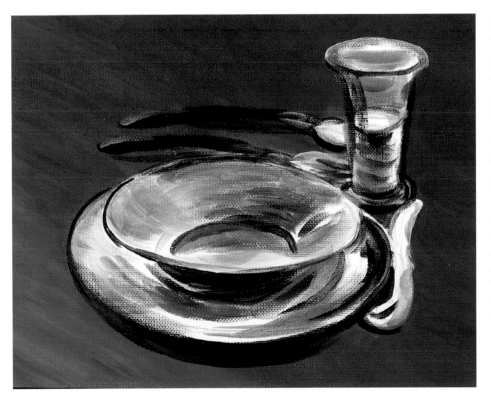

3 The Awkward Stage

Now it is time to create the form of the place setting with other colors. Continue "drawing" in the shapes with a no. 2 round brush and diluted paint. Make the brushstrokes consistent with the shape of the objects. You can see the roundness and circumference of the bowl, dish and glass within the brush strokes. At this stage, establish the overall color of the objects, using different tones to create the shadows and highlights. Use black tones in the shadow areas and in the handles of the silverware. When you create the shadows, you're also indicating the direction of the light source.

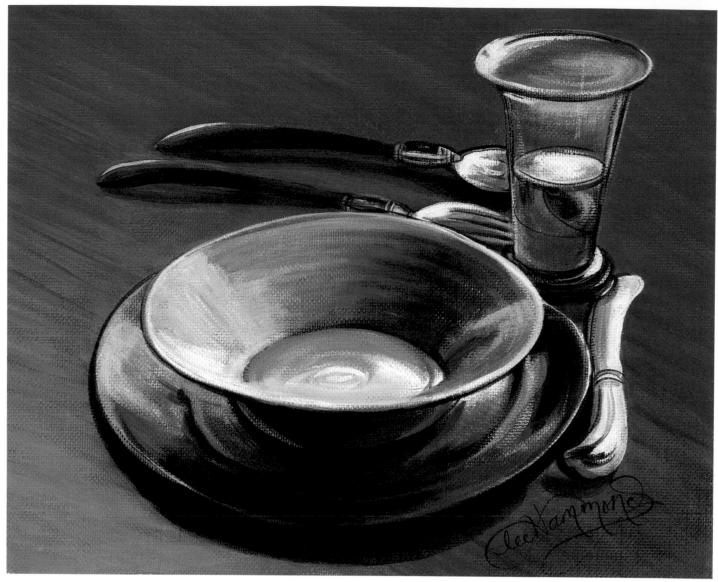

Place Setting
8" × 10" (20cm × 25cm)

4 Finish

Most of this step is done with the no. 2 round brush. Continue to build layers of color for good coverage, using distinct brush-strokes that are consistent with the shapes. Use a small liner brush with Ivory Black and Titanium White to create the lights and darks around the rims of each object.

You can see that the ceramic has a bit of a mauve color to it. You actually do not need any blue to create this color. Simply add a touch of Ivory Black to a mixture of Burnt Umber and White. There is, however, a touch of Prussian Blue in the subtle green seen reflected in the drinking glass.

There are a lot of reflections on the objects in this piece. Once the paint layers have been built up, use the small liner brush and Titanium White to create the small edges of reflected light along the rims of the various surfaces. You can see these edges on the rim of the bowl, the rim of the plate, the rim of the glass and along the edges of the silverware. Use Ivory Black the same way for the dark contrast along these edges.

DEMONSTRATION
USING COMPLEMENTS

Complementary colors can make a painting come alive. Red is my favorite color. I love it for its brilliance and vibrancy. To enhance red, use its opposite on the color wheel, green. Look at the graphed reference photo and you can see how much more impact my version has than the photo.

MATERIALS LIST

Paints
- Burnt Umber
- Cadmium Red Medium
- Cadmium Yellow Medium
- Ivory Black
- Prussian Blue
- Titanium White

Brushes
- no. 3 sable or synthetic filbert
- no. 2 sable or synthetic round
- no. 2 sable or synthetic liner

Canvas or Canvas Paper
- 16" × 12" (41cm × 30cm)

Other
- mechanical pencil
- kneaded eraser

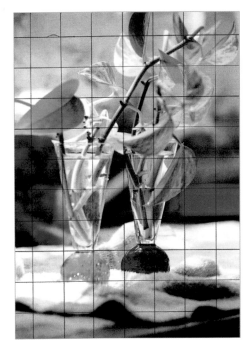

A Graphed Photo
The plants in your painting do not need to be as complex as the ones in the photo. A reference photo is for reference only; you need not become a human copy machine. You can make changes to improve your composition.

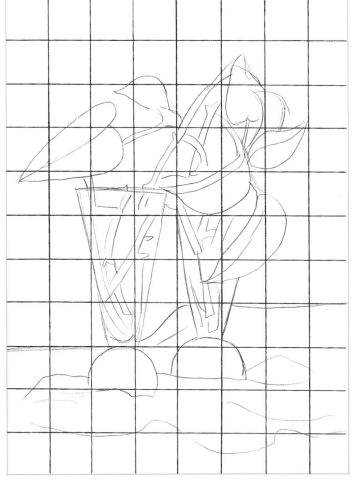

1 Draw the Subject
Follow the graphed example, and create this line drawing on your canvas paper. Simplify the plants to create a more dramatic painting. When your drawing is accurate, erase the grid lines.

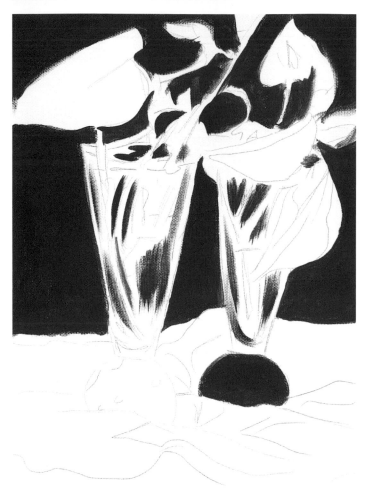

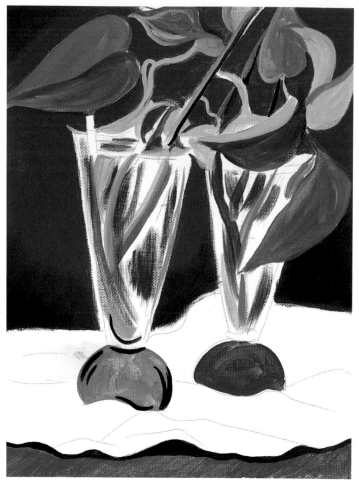

2 Paint the Background and the Red Glass

With Cadmium Red Medium and a no. 3 filbert brush, fill in
the background areas, including those between the leaves. (Use
a no. 2 round for smaller areas.) Red can be a streaky color, and
you may need to use a couple of coats. Paint in the base of the
shot glass on the right. Add some red inside the glasses to indi-
cate that they are transparent.

3 The Awkward Stage

Create an emerald green color by mixing a dab of Prussian
Blue into some Cadmium Yellow Medium. Use this and a no.
2 round to fill in the larger leaves and the base of the other shot
glass. Add more yellow to the mix to get a lighter green, and use
this to fill in the stems and remaining leaves.

To give the background some depth of tone, like an illusion
of shadows, add some Ivory Black to Cadmium Red Medium
and place this darkened red into the corners and along the area
above the table line. This instantly gives the painting more
impact.

With Burnt Umber, fill in the area along the bottom edge of
the painting to suggest a wooden tabletop. Layer on some Ivory
Black to create a shadow underneath the tablecloth.

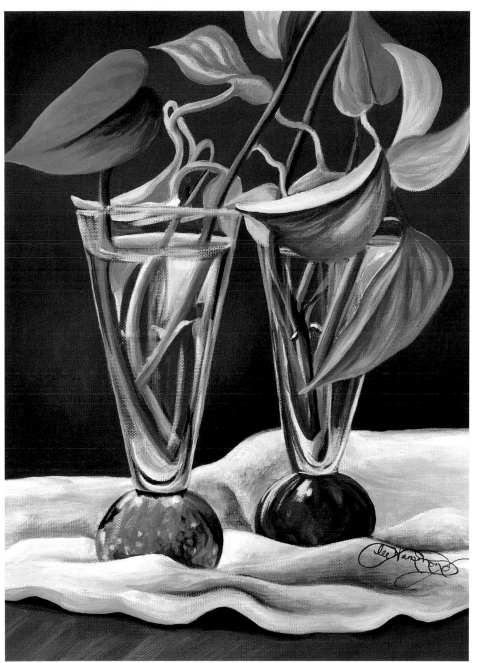

4 Finish

This final step is a lengthy one with many small details. Fill in the tablecloth with a coat of Titanium White. Then add shadows to it with a blue-gray mixture made of Titanium White, Ivory Black and a touch of Prussian Blue. The "rolls" in the fabric resemble cylinders and have all of the five elements of shading we saw in the sphere on page 29. Correctly capturing these light and dark areas will result in convincing folds.

Add more of the dark red from step 3 into the background. Use the dry-brush technique (see page 26) with a filbert brush to blend this darker red into the first layer of red. Adding the darkness helps create a natural framework, leading the eye into the center of the painting and to the main focal point.

With a liner brush, add all of the small details to the many surfaces of this piece. For instance, add small streaks of light and dark green to the leaves to make them look like philodendrons. Add light edges to some of the leaves and to the stems.

Add light edges to the rims of the glasses and inside the glasses where the stems come together. These small swipes of white make the glass look very reflective.

For the bases of the shot glasses, use dabs and streaks of white and black to give them form and patterns. These patterns make the bases look rounded. They also make the glass appear to be "bubbled" inside.

Reds and Greens
16" × 12" (41cm × 30cm)

tip

Reflected Colors Create a Realistic Look

Can you see how the base color of each glass is reflected up into the glass itself? Their colors are also reflected onto the white tablecloth. To create the reflected colors on the tablecloth, I used the same scrubbing method as with the background.

landscapes

LANDSCAPES ARE ONE OF THE MOST POPULAR subjects for artists. Not only do they provide beautiful colors to capture (as in the skies and seascapes we will cover first), the additional subject matter within a landscape helps tell a story.

The previous chapters gave you the information required to help you paint anything you want to paint in acrylic. To become proficient at any skill requires constant practice and repetition. Skies and water are a good subject on which to practice and perfect your painting skills. I can't think of a better way to get used to the feel of the paintbrush in your hand. You can also refer back to the brushwork exercises and examples on pages 23–27.

MONOCHROMATIC SEASCAPE

A scene such as this one looks much more complicated than the projects in earlier chapters, but it is actually extremely simple. Because of the black-and-white color scheme in this project, you can really concentrate on the tones and painting techniques. Another nice thing about an outdoor scene such as this is you don't have to use the grid method to get it on the paper because accuracy of shapes is not critical to a basic landscape painting.

In this piece you will also get to practice blending tones smoothly on the canvas.

MATERIALS LIST

Paints
Ivory Black
Titanium White

Brushes
no. 8 sable or synthetic flat
no. 2 sable or synthetic round
no. 2 sable or synthetic filbert
no. 1 sable or synthetic liner

Canvas or Canvas Paper
12" × 16" (30cm × 41cm)

Other
mechanical pencil
ruler

AN AWKWARD COMPOSITION

BETTER

BETTER

1 Horizon line
2 Sky area
3 Ground or water area

1 Plan Your Composition

Outdoor scenes start with a simple horizon line (1). This is where the sky (2) and the ground or water (3) meet. As a general rule for any landscape, be careful not to cut your composition exactly in half with the horizon line. If you do, the viewer's eye won't know what to focus on first. Place the horizon either above the middle of your canvas (to emphasize the ground or water area) or below it (to emphasize the sky area).

For the seascape that begins on the next page, we will place the horizon line above the middle of the canvas.

2 Sketch, Then Paint the Base Tones

Using a ruler, draw a horizon line somewhat above the middle of the canvas.

Add some Ivory Black to Titanium White to make a medium gray. Add a few drops of water to help the paint move, but don't let it become transparent. Using a no. 8 flat brush, paint the entire area below the horizon with sweeping back-and-forth strokes. Apply the paint heavily so it completely covers the canvas.

Begin painting the sky with the same gray, starting at the top and working down. While the sky is still wet, add some white to the gray and keep painting down toward the horizon. Quickly blend the tones together. Add more white to the mix and quickly blend in some streaks that resemble clouds. If you end up with more clouds than mine, that's okay. Use a clean hake brush to blend the sky once more.

3 The Awkward Stage

With pure Ivory Black and a small round brush, paint in the silhouettes of the rocks. Start with the big rock and make the others smaller as they recede into the background. Also drybrush a few waves in the foreground with Ivory Black.

With a medium gray and the same small round brush, suggest waves under the big rock and along the shoreline.

Mix a very dark gray—almost black—and paint the ground along the shoreline. Work down, gradually adding more white to the mix to make the ground lighter as you approach the bottom of the canvas.

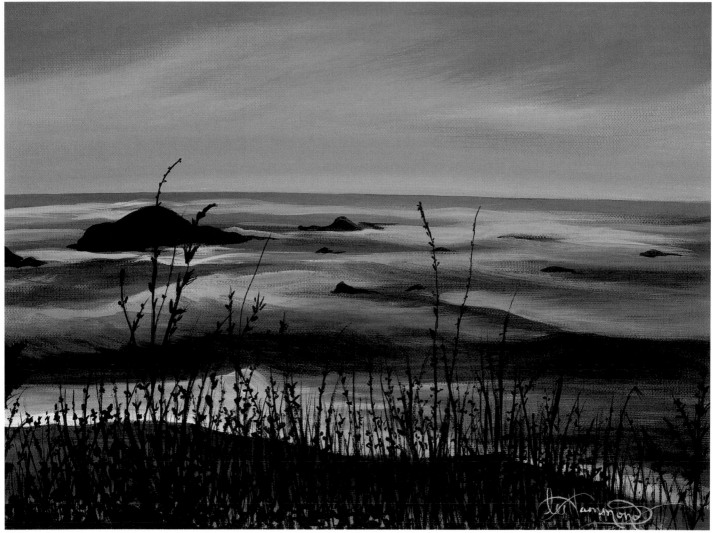

4 Finish

Mix a light gray and paint waves with sweeping strokes and a no. 2 filbert brush. Study my example and watch the direction of the flow, and how they work off of the rocks. Let the direction of your brushstrokes depict the movement of the water.

Thin some pure Ivory Black with water to an inklike consistency, but do not let it become transparent. Paint the reeds with long, quick, tapering strokes of a no. 1 liner brush, starting at the bottom of each reed. Refer to page 25 for the technique.

Add the little leaves with small dabs from the tip of the liner brush. I like the way the black silhouette of the reeds contrasts against the shore. The lightest wave area at the shoreline seems to glow between the reeds.

The Atlantic in Winter
From a photograph
by Janet Dibble Wellenberger
12" × 16" (30cm × 41cm)

SEASCAPE IN COLOR

This painting is done using the same colors as the previous demonstration on pages 59–61, but this time we are adding some Prussian Blue—and this time, the horizon line is below the center of the canvas, placing the emphasis on the sky. For such a beautiful painting it certainly is an easy one to do!

MATERIALS LIST

Paints
 Ivory Black
 Prussian Blue
 Titanium White

Brushes
 no. 6 sable or synthetic flat
 no. 4 sable or synthetic filbert
 no. 2 sable or synthetic round
 hake brush (for blending)

Canvas or Canvas Paper
 9" × 12" (23cm × 30cm)

Other
 mechanical pencil
 ruler

1 Draw the Horizon and Base In the Colors

Draw the horizon line with your ruler and pencil. Mix a sky-blue color with Prussian Blue and Titanium White. Paint the sky with your no. 6 flat brush, working from the top down and adding white as you go. Use your hake brush to help the colors blend. Some streaking will give your sky atmospheric movement. Let the sky color overlap the ground area a bit.

Fill in the entire water area with pure Prussian Blue on the no. 6 flat brush. Use a horizontal back-and-forth stroke. If some streaks show, that's okay; they'll become part of the water's surface look.

2 The Awkward Stage

Using a no. 4 filbert, paint the largest mountain range with the sky color from step 1 mixed with a bit of Ivory Black. Lighten the mix on your palette with a little Titanium White, then add the smaller mountain. Now add more black into the mix and create the darkest mountain in front of the other two. Be sure that all of them end at the horizon line, and that the horizon looks straight.

Add streaky clouds with Titanium White, using a no. 2 round brush and horizontal strokes. It is okay to allow the color behind them to show through. The horizontal brushstrokes help maintain the feeling of atmosphere and wind movement.

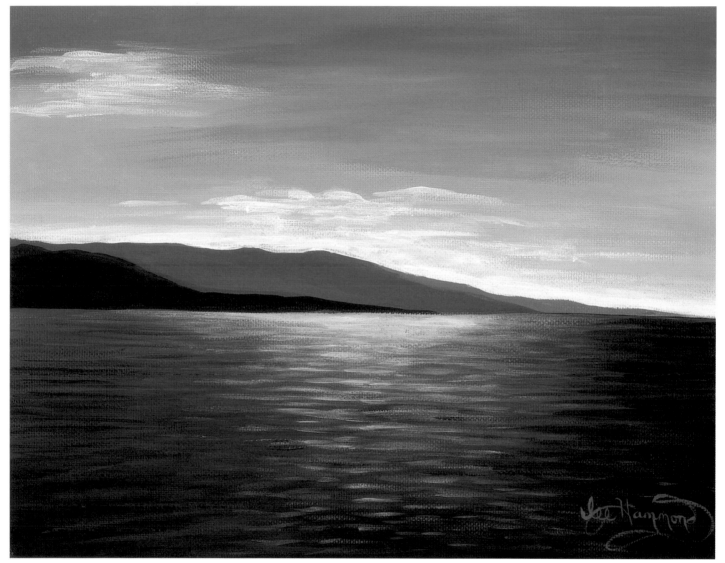

3 Finish

Detail the water with quick horizontal streaks of Titanium White on a no. 2 round brush, creating a mirror reflection of the white clouds in the middle. For the rest of the water, use the same quick horizontal stokes, but vary the colors from dark to light. The result will be a feeling of water movement and sparkling sunshine. I painted this from a photo I took on one of my "art cruises" in Jamaica. Amazingly, these were the actual colors of the scene; I haven't altered them for this painting. Beautiful!

Jamaica
9" × 12" (23cm × 30cm)

CLOUDSCAPE

Sometimes an entire scene can be created from a sky alone. Clouds have a way of creating their own story and composition. The bonus to a sky composition is that it requires no horizon lines or grids! All you need is a free spirit and some paint! The sky offers you the opportunity to experiment to your heart's desire, because there is no right or wrong.

MATERIALS LIST

Paints
Prussian Blue
Titanium White

Brushes
no. 6 sable or synthetic flat
no. 4 sable or synthetic filbert

Canvas or Canvas Paper
8" × 10" (20cm × 25cm)

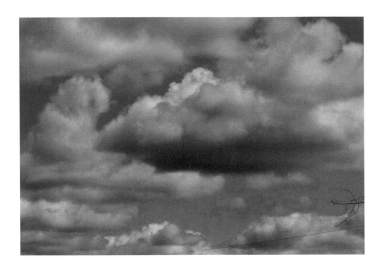

REFERENCE PHOTO

I love this photograph. It shows the full softness of billowy clouds. I particularly like the way the colors of the clouds in this photo range from very white to pale blue to the dark blue of the large cloud's underbelly. The sense of distance is evident in the way the clouds get smaller as they recede into the background.

1 Paint the Base Colors

Add a touch of Titanium White to Prussian Blue to create a medium blue. With wide sweeping strokes, cover the upper portion of the canvas. Be sure to add a touch of water to the paint to make it smooth, but it still needs to be opaque.

The sky is darker at the top and gets lighter the closer it gets to earth. So as you work down, add a bit more white paint to the mixture to create more of a sky blue. Continue down the canvas, lightening as you go. Use rapid strokes while the paint is wet to soften the tones into a very gradual color transition.

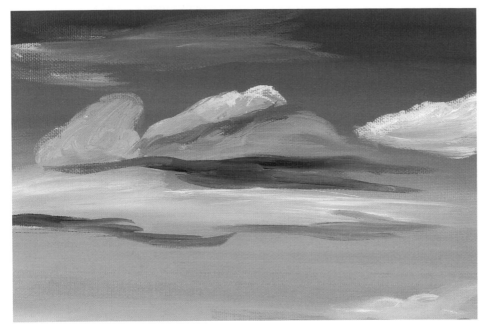

2 The Awkward Stage

Using pure Titanium White, create the shapes of the clouds with your filbert brush. Do not make the paint so thick that it builds up. We don't want rough texture for fluffy clouds. Lightly blend the white into the background to make the edges soft.

Clouds are layered and have dimension. To give them form and make them look full, blend shades of blue, from dark to light, into the white using a no. 4 filbert brush.

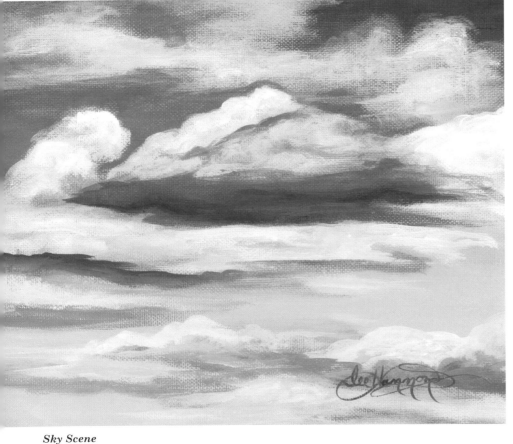

Sky Scene
8" × 10" (20cm × 25cm)

3 Finish

Add the shadows of the clouds with many varied shades of Prussian Blue. The more shades you use, the more realistic your painting will be. Some of the clouds are painted "light over dark," while others are "dark over light."

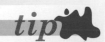

Take Time to Layer Your Paint

The wonderful thing about acrylic paint is the ability to keep layering and adding lights and darks, blending them together as you go. Don't give up too soon! It takes practice to learn brush control. It also takes time to build up realistic details.

TROPICAL SKY

If you are lucky enough to travel far from home, you'll get to see the sky in a different environment—and even if you don't travel, the sky right where you live is a constantly changing show of color and light. Keep a camera handy just in case nature decides to give you a photo opportunity.

To complete this painting, you will use all of the blending techniques we have already covered; you'll just change the colors. This sky has a lot of movement. The horizontal streaks are very apparent, so you can use the paint strokes to your advantage by letting them show instead of blending the strokes perfectly.

MATERIALS LIST

Paints
 Alizarin Crimson
 Cadmium Red Medium
 Cadmium Yellow Medium
 Ivory Black
 Titanium White

Brushes
 no. 6 sable or synthetic flat
 no. 4 sable or synthetic filbert
 no. 2 sable or synthetic round

Canvas or Canvas Paper
 12" × 16" (30cm × 41cm)

Other
 mechanical pencil

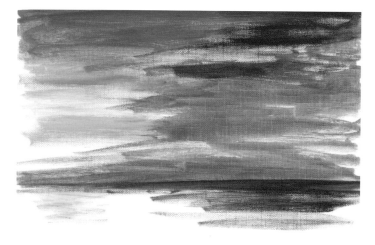

1 Sketch, Then Paint Base Colors

Find your horizon line and lightly draw it on the canvas with a pencil. This horizon line is very close to the bottom of the page, allowing for a huge sky scene. On your palette, you will need your warm colors: Cadmium Yellow Medium, Cadmium Red Medium and Alizarin Crimson. You will also need Ivory Black and Titanium White.

Mix a variety of coral colors on your palette using Cadmium Red Medium, Cadmium Yellow Medium and a touch of Titanium White. It is not important to exactly match each color I've used. As with all outdoor scenes, you'll paint from back to front. With your flat brush, start laying in the colors of the sky. Look where the sky is lighter due to the sun, and block in some yellow and white. This is where the sun glow will come from.

Now create the redness of the sky by streaking in the other warm colors with the no. 6 flat brush. Dilute the paint so you can move it quickly. Transparent mixtures are okay. My students call this my "slapping-in stage"! You can see where I used a wide range of reds, from light ones (tints) to dark ones (shades). Have fun applying quick strokes of color. There is no set "recipe" here, no right or wrong.

Take some Alizarin Crimson and Cadmium Red and mix in a touch of Ivory Black. Paint this dark color along the horizon line. Add some of the colors from the sky area into the water area for the mirror image affect.

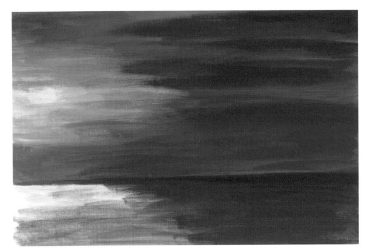

2 The Awkward Stage

Build up the paint with the same colors you used in step 1. Use less water now so that the paint is more opaque and can cover up the canvas. Use quick horizontal strokes to create the streakiness of the sky. Unlike the paintings in earlier demonstrations, this sky does not have to be repeatedly blended for smooth transitions of color.

3 Finish

When you like the colors of your painting and you have completely covered the canvas with a smooth application of color, you can add finishing touches. Add the sparkle of the water where it reflects the sun using white paint. Double-check the painting to be sure everything is covered, because once the trees go in, there is no redoing the background.

Lightly draw in the trunks of the palm trees with your mechanical pencil. You can add some more trees if you'd like. Do not draw in every palm frond, however; those will be created with your brush.

Thin down some Ivory Black with a touch of water. Make it thin enough to flow, but not so thin that it becomes transparent and streaky. Fill in the trunk with this black mixture and a no. 2 round brush.

Before you add the palm fronds, I suggest you practice first on a scrap piece of canvas. Paint them with quick, very small strokes, from the stem outward. This way the lines will taper at

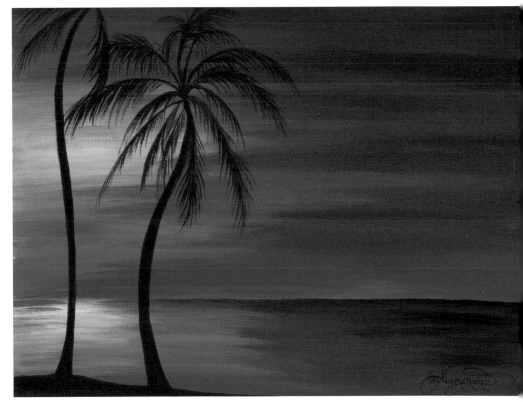

A Celebration of Sun (Puerta Vallarta, Mexico)
12" × 16" (30cm × 41cm)

the end and become thinner. If you paint from the "outside in," the ends will be wide and unnatural-looking.

Be sure to add a little bit of sand at the bottom, so your trees look planted!

STORM CLOUDS

I viewed this sunset right from my porch in Kansas. We have some pretty intense weather here (remember *The Wizard of Oz?*) and this was the scene as a thunderstorm was rolling in. The difference between this painting and the one on page 67 is that here we have more color changes and more contrasts in color. There is also no foreground subject matter to deal with this time.

This sky has a distinct sense of distance within it. The yellow glow of the sun seems much farther back, while the clouds seem very close. This is due to the intense contrast between the two.

MATERIALS LIST

Paints

Alizarin Crimson
Cadmium Red Medium
Cadmium Yellow Medium
Ivory Black
Titanium White

Brushes

no. 6 sable or synthetic flat
no. 4 sable or synthetic filbert
9" × 12" (23cm × 30cm)

Canvas or Canvas Paper

16" × 12" (41cm × 30cm)

1 Paint the Sky's Base Colors

Mix Titanium White with a touch of Cadmium Yellow Medium. Thin the mix with water so it will move easily but not so much that it becomes transparent. Apply this pale yellow starting at the top of the canvas with a flat brush and sweeping back-and-forth strokes. Alternate with strokes of pure white, then blend the yellow and white into each other.

As you work down the canvas, add more and more Cadmium Yellow Medium to create warmth. Mix a touch of Cadmium Red Medium into the yellow to create orange, and add that into your sky at the bottom. Streaky brushstrokes are okay; they will suggest the movement of air.

2 The Awkward Stage

To create colors for the clouds, start with the yellows and oranges you mixed for the background and add some Alizarin Crimson to them. This will give you deeper reds and pinkish colors. Streak these onto the canvas with horizontal strokes and a filbert brush. Use many different tones—whatever's on your palette.

Now, mix touches Ivory Black into the colors on your palette and streak the resulting browns, mauves, corals and grays onto your sky. This is the fun part. Be creative, but do not completely cover up the light sky you painted in step 1. Make layers and let the light glow of the sky show through from the distance.

3 Finish

Continue adding layers of paint until the canvas is covered and you like your painting. If you love the color orange, go ahead and use more. Or add more red if you like. Study my painting to see where I streaked in the different colors.

Add the pure black silhouette of the hill on the bottom, and you are finished!

Before the Storm
16" × 12" (41cm × 30cm)

LANDSCAPE WITH PERSPECTIVE

This painting project is similar to the preceding ones in this chapter, but we're adding an element—the road—that creates perspective. In this project you'll learn how to use the technique of foreshortening to create the appearance of depth and perspective on a flat piece of canvas.

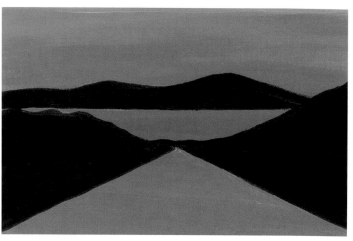

1 Paint the Base Color, Then Draw

Mix a medium gray using Ivory Black and Titanium White and cover your canvas to look like mine. Let dry.

With your mechanical pencil, draw in the horizon line. Use a very light touch to keep from scratching the paint. The horizon line, where the lakeshore meets the mountains, is below the center point of the canvas.

Draw in the highway as well. It is a large upside-down V shape. This piece is a clear demonstration of foreshortening. The highway is receding (getting smaller) as it heads into the background, which illustrates a huge amount of distance.

2 The Awkward Stage

With pure Ivory Black, base in the mountain range that creates the horizon line. Fill in the V-shaped areas of ground on either side of the highway. At this stage, you already have a feel for the landscape and the distance.

Create Depth With Foreshortening

Look at step 3 and compare the width of the road at the bottom of the canvas with where it disappears into the distance. Common sense tells us that the road is the same width all the way back, but it appears to get smaller. This is called foreshortening, and it is an important technique that will give your paintings a feeling of depth and space.

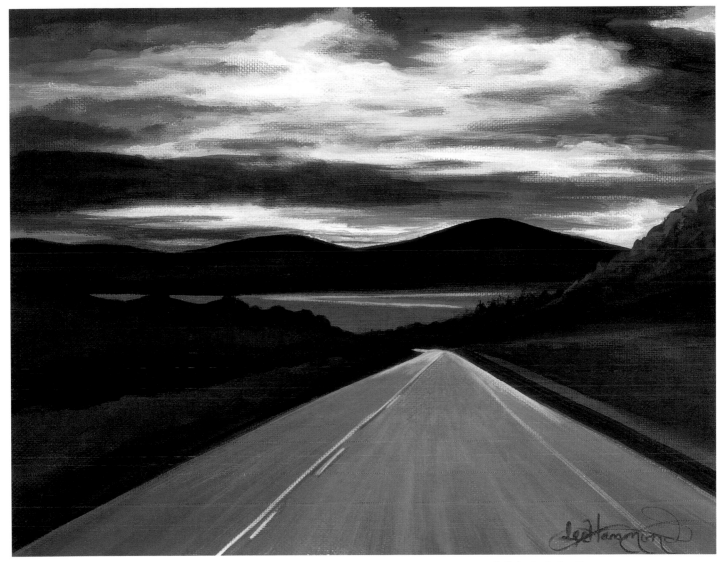

A Trip to Lake George
9" × 12" (23cm × 30cm)

3 Finish

Mix a light gray and start placing the clouds. Once you like the shape and movement of them, add pure Titanium White to them to make them appear fluffy. Add some dark gray clouds, streaking them into the lighter ones for more depth of tone and sense of distance.

Go into the solid black areas of the mountain and the ground and give them some very subtle texture with a dark gray. This gray is just one tone lighter than black, but it helps keep things from looking flat.

With light gray, add the details to the water. Just two light-gray lines are enough to suggest a reflection. Add the highway divider lines. With a lighter gray, streak the highway pavement, keeping consistent with the V shape. Make the pavement lighter as it fades into the distance.

ATMOSPHERIC PERSPECTIVE

Trees are an important element for landscape painting. Entire books have be written just on how to draw and paint the many varieties of trees. We've already learned how to paint a palm tree (see page 67). This simple project will give you some practice painting evergreens.

I've used a monochromatic color scheme, but not because I wanted to skimp on color. This foggy scene in Vermont really looked like this. All I could see were various shades of green fading in and out of the morning mist. Notice that the trees appear to get lighter as they recede into the distance. In this project you will learn how to use that phenomenon, called atmospheric perspective, to create depth in a landscape.

Usually I paint the sky first and then work back to front. This time, however, I am going to leave the sky white.

MATERIALS LIST

Paints
Cadmium Yellow Medium
Ivory Black
Prussian Blue
Titanium White

Brushes
no. 2 sable or synthetic round
no. 4 bristle flat
no. 2 sable or synthetic
liner brush

Canvas or Canvas Paper
10½" × 10½" (27cm × 27cm)

1 Rough In the Tree Shapes

You'll start this painting by drawing the trees in with paint. Mix a small amount of Prussian Blue into some Cadmium Yellow Medium to create a green mixture. Then add some Titanium White to make a pastel version and dilute this a bit with water. Using a no. 2 liner brush, paint vertical lines to represent tree trunks. This establishes the placement of the trees in the painting.

Once you have the trunks based in, switch to a no. 2 round brush and add branches and limbs with a somewhat squiggly back-and-forth stroke. The trees should be smaller at the top and get larger at the bottom, forming a cone shape. Paint loosely and don't let your strokes fall into too much of a repeating pattern.

tip

Atmospheric Perspective

Elements receding into the background of a landscape appear not only smaller, but also lighter in color the farther back they are. Also, the farther back something is, the more of the sky color it will take on. This is called atmospheric perspective.

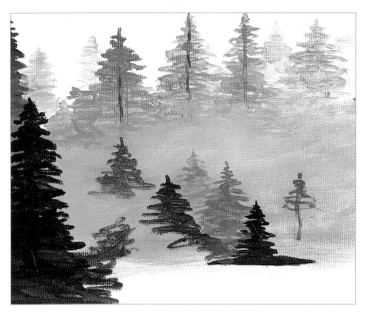

2 The Awkward Stage

Take some of your green mixture and add a little more white to it. Scrub this color into the area at the middle of the painting using a no. 4 bristle flat. Take some of the darker green mixture that you used for the trees in step 1 and add some Ivory Black into it. Use this mix and a no. 2 round to add dark trees in the foreground. Paint these trees larger so that they appear closer. Lighten the mix with a bit of white as you work into the distance. Closer trees should appear larger and darker; distant trees, smaller and lighter.

Use a bit of darker green to indicate bits of tree trunk on the distant pines.

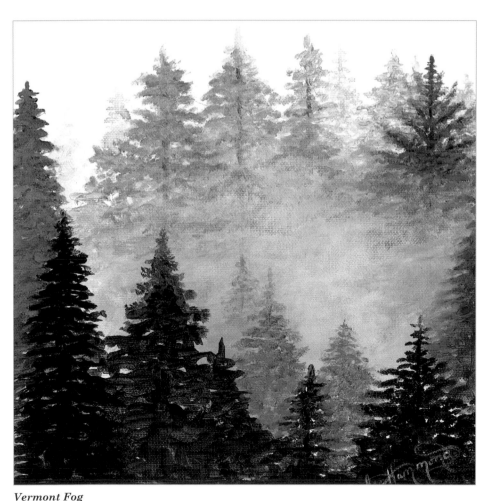

Vermont Fog
10½" × 10½" (27cm × 27cm)

3 Finish

Add more layers of trees. Look closely at my painting to see how I altered my painting with subtle layers of different tones.

Once you have all of the darker trees added to the foreground, take a stiff bristle flat with Titanium White and literally scrub some fog into the center area. Let the paint start to get thin, and scrub right over the trees. You should be able to see the trees through the paint.

A CHALLENGING TREE SCENE

As you can see, the landscape projects in this chapter have become increasingly more detailed. This park scene will challenge you to perfect your skills.

While this painting may look extremely complicated, it has all of the same techniques you have already used in the previous exercises. The only difference is you will now learn how to paint foliage. The sponging technique you'll use for this (see page 26) is really fun to do.

MATERIALS LIST

Paints
 Burnt Umber
 Cadmium Yellow Medium
 Ivory Black
 Prussian Blue
 Titanium White

Brushes
 ¾-inch (19mm) sable
 or synthetic filbert
 no. 6 sable or synthetic round
 no. 4 stiff bristle flat
 no. 2 liner brush

Canvas or Canvas Paper
 12" × 16" (30cm × 41cm)

Other
 cellulose kitchen sponge

1 Draw and Paint Base Colors

Lightly draw the horizon line a bit above the center point of the canvas. Mix a sky blue out of Titanium White and a touch of Prussian Blue. Thin it with water. Cover the sky portion of the canvas with a transparent application of paint using a ¾-inch (19mm) filbert and horizontal strokes. Most of this paint will be covered up later, but it is important to have the sky color as a base so that it can peek through the leaves in spots.

Mix a light green out of Cadmium Yellow Medium and a touch of Prussian Blue. Using the same type of application as you did for the sky, cover the entire area below the horizon line.

2 Paint the Tree Trunks

The placement of the trees in this piece is very important to establishing a sense of depth. While your trees do not have to look exactly like mine, you should pay particular attention to the size relationships between the trees. This composition has a distinct background, middle ground and foreground. The trees are sized in relationship to their placement within these three areas. Block in the trees with diluted Ivory Black and a no. 6 round, starting with just the trunks and the major branches.

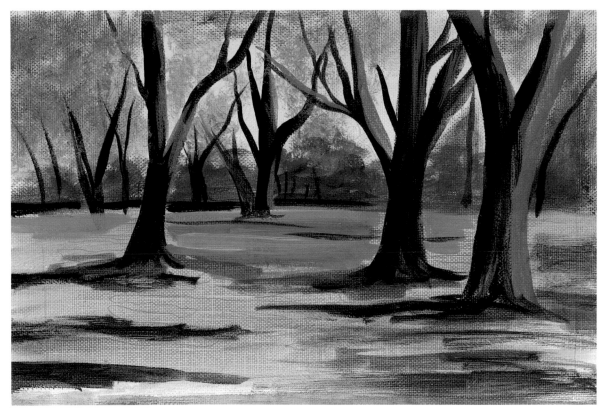

3 The Awkward Stage

Mix Cadmium Yellow Medium and Prussian Blue to create a dark green. Scrub this color right above the horizon line with a no. 4 flat bristle brush to create a tree row, or what is also called a hedgerow. This dark green is another foundation color upon which you will build later.

Take a cellulose (not foam!) kitchen sponge and tear off a chunk about an inch around. Lightly wet it and squeeze out any excess water. Lighten the dark green mixture from step 2 by adding a touch more Cadmium Yellow Medium. Dip the sponge into this and lightly dab some color into the background above the dark green hedgerow. Look at the texture this technique creates! It is a perfect representation of distant foliage.

Mix a touch of white into some Burnt Umber. Apply some of this to the right sides of the trees and branches with a no. 2 liner brush. This establishes that the sun is coming from the right.

Now it is time to build up the ground color. The first application was somewhat transparent and streaky. We now need to thicken the paint and look for the patterns of light and dark to create the illusion of shadows and streaks of sunshine. The entire ground is nothing more than streaks of color. Use a full range of greens and various mixes of brown and a no. 6 round. By now, you should be able to take the colors on your palette and experiment to create the colors you want.

Don't Quit Too Soon!

This is the stage of the painting that looks very awkward. This is also the stage of the game where many beginning artists have a tendency to give up. Please don't! This is where the real learning comes in, and your skills can grow exponentially. All paintings pass through this "yucky" stage. It is a necessary part of the process.

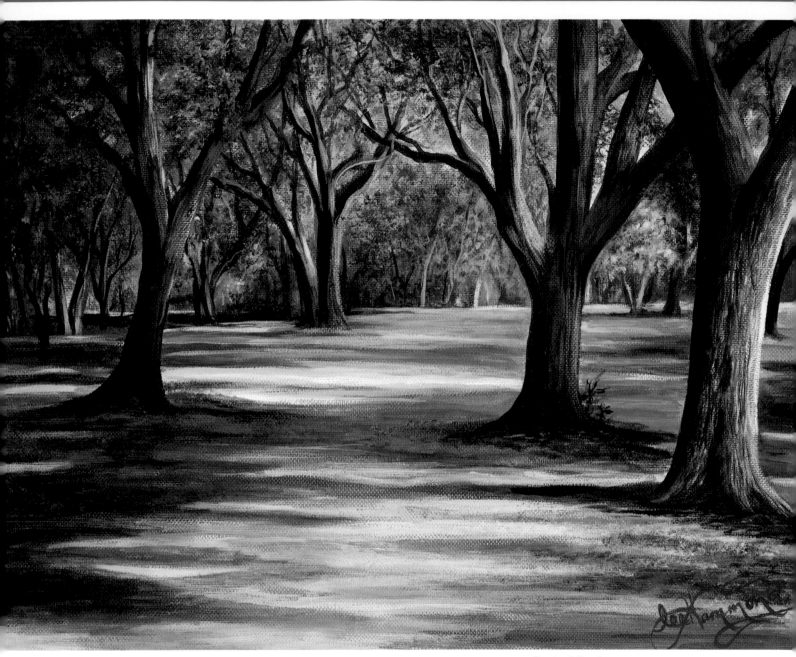

4 Finish

This is a fairly large painting with many details, so I've focused in on three small areas of the painting so you can see them better. Let the enlarged details on the facing page be your guide to finishing the painting.

Central Park
12" × 16" (30cm × 41cm)

Learn From Finished Paintings

You can learn a lot by studying other artists' finished paintings up close. Try going to an art gallery and looking at the brushstrokes each artist used. Many times, what looks complicated is nothing more than quick dabs of color.

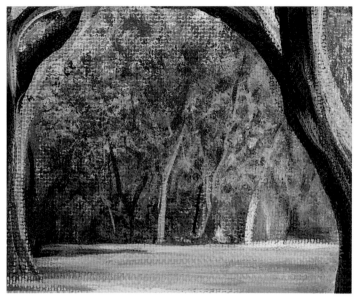

DETAIL: BACKGROUND HEDGEROW

To create the look of dense brush, use your sponge to dab in many layers of color. Then use a liner brush to add tiny branches amongst the foliage layers.

DETAIL: TREE BARK

Use a dry-brush technique (see page 26) to create the texture of tree bark. Concentrate on each tree's right side, where the sun is brightest. Layer light and dark paint, and use tiny brushstrokes for realism.

DETAIL: THE GROUND UNDER THE LARGE TREES

Build up the ground around the bases of the large trees using a combination of brushstrokes and sponge dabbing. You can dab with a bristle brush as well as the sponge.

flowers

WITH THE LANDSCAPE PAINTINGS IN THE PREVIOUS chapter, you were painting an entire scene from foreground to far in the distance. You used patterns of light and dark to create the illusion of shapes that look realistic at a glance.

For the flower paintings in this chapter, details are more conspicuous, and accuracy becomes more of an issue. While you could include flowers in a landscape and represent them with little dabs of color, this chapter will show you how to paint an entire flower up close.

To capture all of the shapes and details of flowers, we will once again rely on the grid method of drawing (see pages 36–37). This wonderful tool will allow you to create accurate, beautiful flower paintings.

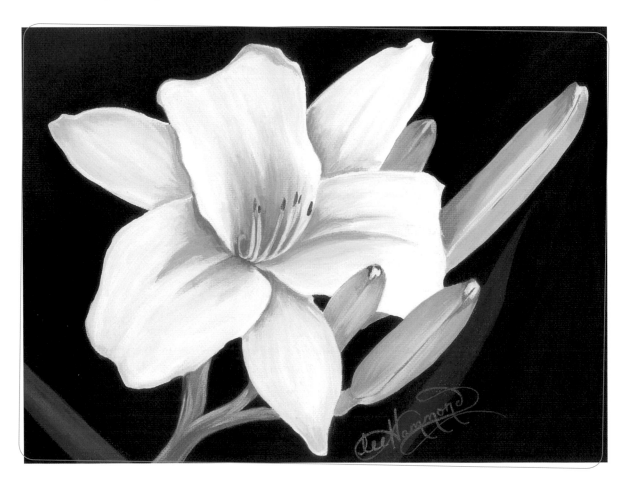

FLORAL VALUE STUDY

Painting your first flower project with a monochromatic color scheme may seem strange, but it is an excellent way to concentrate on shape and values without being confused by color.

MATERIALS LIST

Paints
> Ivory Black
> Titanium White

Brushes
> ¾-inch (19mm) sable or
> synthetic filbert
> no. 2 sable or synthetic round
> no. 2/0 sable or synthetic round

Canvas or Canvas Paper
> 8" × 9" (20cm × 23cm)

Other
> mechanical pencil
> kneaded eraser

A GRAPHED PHOTO
This photo with a grid over it will be your guide to painting the rose realistically. Refer back to page 36–37 to refresh yourself on how to draw using the grid system.

Let the Darks Create the Lights

For realistic results, avoid outlining every shape you paint. Instead, let the dark shapes create the edges of the light shapes. In this case, the black background describes the shape of the rose, and dark areas within the petals form the edges of lighter areas.

1 Draw the Rose

Lightly draw one-inch or larger squares on your canvas. Refer to the photo on this page and carefully draw what you see in each square. When you are sure you have an accurate line drawing, gently remove the grid lines with a kneaded eraser.

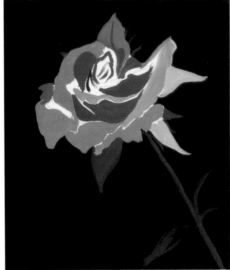

3 The Awkward Stage

The flower is made up of tones ranging from white to very dark gray. Study the photo well and see where the lights and darks are. Start by establishing the petal edges with Ivory Black and a 2/0 round brush. This creates the layers. Mix various grays out of Ivory Black and Titanium White, then lay in blocks of tone to create each overlapping petal, leaving the lightest areas unpainted for now. The tones will cover up the black edge lines you made initially. Fill in the stem as well.

2 Fill In the Background

Outline around the rose with pure Ivory Black and a no. 2 round so you can get close to the edges of the flower, leaves and stem. Then, with your ¾-inch (19mm) filbert, fill in the rest of the canvas surrounding the flower, making the entire background pure black.

4 Finish

Detail each petal one at a time. Look for the patterns of light and dark. Every petal has different tones depending on the way the light is hitting it. Acrylic paint allows you to add layers over and over until you get it the way you like it.

Be very careful not to outline each petal. Anything with an outline surrounding it will look more cartoony than realistic.

To make the background more interesting and not so flat, scrub dark gray into some areas to suggest leaves.

Later, if you like, you could come back and try painting this rose in realistic pink hues!

Monochromatic Rose
8" × 9" (20cm × 23cm)

DEMONSTRATION
PETALS IN COLOR

In the previous monochromatic demonstration, you learned to create layers of flower petals by letting the darks create the lights. Now we'll try it in color with a lily.

The rose on the previous exercise was extreme in its tonal range. The tonal variations in this lily are much more subtle. Like the rose painting, this one uses a dark background to create the flower's shape.

MATERIALS LIST

Paints
Cadmium Red Medium
Cadmium Yellow Medium
Ivory Black
Prussian Blue
Titanium White

Brushes
¾-inch (19mm) sable or
 synthetic filbert
no. 2 sable or synthetic round
no. 2/0 sable or synthetic round

Canvas or Canvas Paper
11" × 14" (28cm × 36cm)

Other
mechanical pencil
kneaded eraser

A Graphed Photo
Use the grid lines on this photo to obtain an accurate drawing. Remember, you can make your painting as large as you want by enlarging the squares you place on your canvas.

1 Draw the Lily

This is what your drawing should look like after drawing the details of each box one at a time. Gently erase the grid lines from your canvas when you are sure of your accuracy.

2 Basecoat the Petals

Paint the flower petals with Titanium White that has just a hint of Cadmium Yellow Medium added to it, using a no. 2 round brush. To establish the pods and the darkest areas of the flower, use pure Cadmium Yellow Medium. This helps define the overlapping petals and begin the process of creating form.

3 The Awkward Stage

Create an orange color for the center of the lily by mixing Cadmium Yellow Medium with a touch of Cadmium Red Medium. Paint the center of the lily with this color and a no. 2 round. This will help the center of the lily appear recessed. Leave areas of the lighter color exposed for the stamens.

Switch to a no. 2/0 round for the details. Use the orange mix you created for the lily's center to detail the shadow areas in the flower and on the pods. Paint the stem with a green created by mixing a touch of Prussian Blue into Cadmium Yellow Medium. Also streak some of this green into the pods to make them look real. Paint the shadow on the stem with a brown made by mixing some Cadmium Red Medium into the green mix.

Mix Prussian Blue and Ivory Black and start painting the background with this mix and a ¾-inch (19mm) filbert. This defines the outside edges of the petals.

Use Contrast for More Impact

Don't be afraid to use lots of contrast in your paintings. Compare the areas of the flower near the background color to the areas where the background hasn't been painted yet. Isn't it amazing how much the added contrast changes the look?

4 Finish

Continue filling in the background with the dark mixture from step 3. To make it look more interesting, blend in touches of other colors in some areas. Add some light blue and a hint of lavender in the upper left corner. This lavender color acts as a complement to the yellow of the lily. You can add more violet in the background to help contrast against the yellow. Refer to page 17 in chapter two for a refresher on how complementary colors work in a painting.

Add two subtle leaves to balance out the composition. I encourage you to change this in any way you want and make it truly your own piece. Just have fun!

Yellow Lily
11" × 14" (28cm × 36cm)

A BACKDROP OF COLOR

I love this photo for the way the colors play off each other. Even though the background is out of focus, it plays just as important a role in the painting as the main subject. This is a color copy of a digital print, and some of the colors are more bluish than the original, so I adjusted the color in the painting.

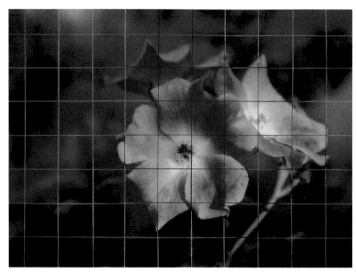

A GRAPHED PHOTO

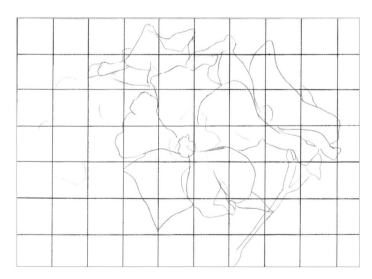

1 Draw the Flower

Using the graphed photo as your guide, draw the flower on your canvas. Make the painting as large as you like by altering the size of the grid squares. When you are sure of your accuracy, gently remove the grid lines from your canvas with a kneaded eraser.

2 Paint the Background

Mix Prussian Blue and Titanium White to create a sky blue color. Cover the entire background with this color and a ¾-inch (19mm) filbert; the blue will be a foundation for the other colors. Let the background color create the edges of the flowers.

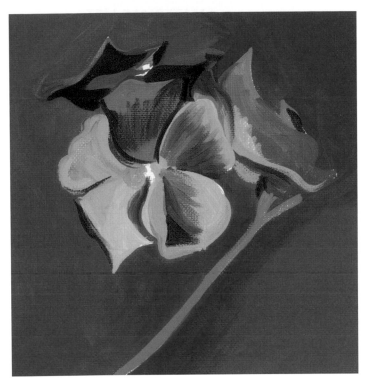

3 The Awkward Stage

Fill in the petals with a no. 2 round and a light pink made of Alizarin Crimson and Titanium White. Add more Alizarin Crimson to the mix to make a darker pink. Use this and a no. 2/0 round to paint the separations between the petals. Some of the shadows require a deeper tone, so add a touch of Prussian Blue to the mix for these.

Add Titanium White to some of the background color to make a light blue and use this to paint the center of the main flower. Mix a mint green using Prussian Blue, Cadmium Yellow Medium and Titanium White; use this to paint the stem.

Pretty in Pink
8" × 10" (20cm × 25cm)

4 Finish

Add various blues, greens and purples into the background by scrubbing the paint in with a ¾-inch flat brush. This allows the colors to overlap one another with subtle edges, similar to a photographer's background. Detail the flowers by drybrushing on various shades of pink and white. Dot on brown and pink with a no. 2/0 round brush in the center of the main flower. Add light green details to both flower centers. Add some subtle leaves with medium and dark greens.

USE A VIEWFINDER TO DEFINE A SUBJECT

This daisy has many of the same colors as the previous project, but it has much more contrast and sharper definition. That and the many, many overlapping petals make this painting seem more intense.

This is actually a small portion of a much larger photograph. The original photo was of an entire vase full of flowers. To isolate the flower I wanted, I made a small viewfinder. I took a piece of black construction paper and cut a two inch square into it with an art knife. I placed this little frame over the photo, moving it around until I captured the image I wanted within the square. I then taped the frame down and had the image enlarged on a color copier.

A viewfinder is wonderful for cropping images and finding minicompositions within larger reference photos.

MATERIALS LIST

Paints
 Alizarin Crimson
 Cadmium Yellow Medium
 Prussian Blue
 Titanium White

Brushes
 no. 8 sable or synthetic filbert
 no. 2 sable or synthetic round
 no. 2/0 sable or synthetic round

Canvas or Canvas Paper
 9" × 8¼" (23cm × 21cm)

Other
 mechanical pencil
 kneaded eraser

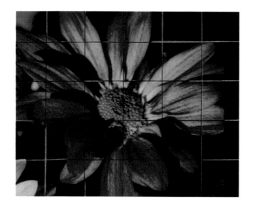

A GRAPHED, CROPPED PHOTO

I made a paper viewfinder to isolate a small segment of a larger photograph.

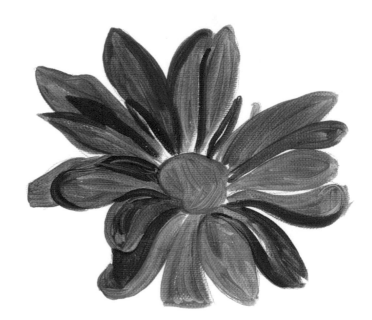

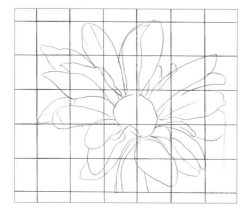

1 Draw the Daisy

Refer to the photo above and use the grid method to draw this flower on your canvas. Take your time; the overlapping petals are crucial to achieving a realistic painting. Make the image as large as you'd like by altering the size of the squares on your canvas. When you are sure of your accuracy, you can remove the grid lines with a kneaded eraser.

2 Paint the Base Colors

Mix a light pink with Titanium White and a touch of Alizarin Crimson. Use a no. 2 round brush to base in all of the petals with this color.

Mix a dark pink by adding more Alizarin Crimson into the white than you did before. Alizarin Crimson is a pretty powerful color, so it doesn't take much to create a deep pink. Use this darker color on a no. 2/0 round to create the streaks in the flower petals. This is where the form of the flower really starts to show.

Mix a light green with Cadmium Yellow Medium and a slight touch of Prussian Blue. Base in the entire center of the flower with this color and a no. 2 round.

3 The Awkward Stage

Use pure Titanium White to streak in highlights on the petals with a no. 2/0 round. Now shade the petals with various pinks, switching among light, medium and dark pink until you like the look of your flower. Refer to the photo as you work.

Remember: Light Over Dark, Dark Over Light

It is important with a flower such as this to establish the separation between petals right away. It is very similar to the approach we took with the black-and-white rose (see page 79). With Alizarin Crimson, paint in the shadows on and under each petal. Do not paint an outline around each one.

4 Finish

Fill in the entire background with Ivory Black on a no. 8 filbert.

To make the texture in the center of the flower, dab in pure Cadmium Yellow Medium with the tip of a no. 2 round brush. Also dab in some Alizarin Crimson along the left edge and near the middle of the flower's center.

Pink Daisy
9" × 8¼" (23cm × 21cm)

FLOWERS IN A VASE

Flowers are beautiful all by themselves, but they're even prettier when enhanced by a vase in a still-life arrangement. This project and the next one showcase flowers in vases.

The vase in this project belongs to my mother. On one of my visits to her house, I saw this arrangement perfectly illuminated by sunshine. I always have my camera with me for times just like this.

I am always careful to balance the lights and darks when photographing my subjects, but this piece turned out better than I expected. The shadows enhance the flower arrangement and divide the background into wonderful geometric shapes.

MATERIALS LIST

Paints
Burnt Umber
Cadmium Red Medium
Cadmium Yellow Medium
Ivory Black
Prussian Blue
Titanium White

Brushes
¾-inch (19mm) sable or
synthetic filbert
no. 2 sable or synthetic round
no. 2/0 sable or synthetic round

Canvas or Canvas Paper
16" × 12" (41cm × 30cm)

Other
mechanical pencil
kneaded eraser

A GRAPHED PHOTO
A photo with extreme contrast between light and shadow can make a beautiful piece of artwork. Contrast is everything!

1 Draw the Flower and Vase

Use the grid method to draw this still life on your canvas. Simplify shapes where you can, because much of your drawing will be covered up in the beginning stages of the painting. Concentrate on the large shapes. Erase the grid lines.

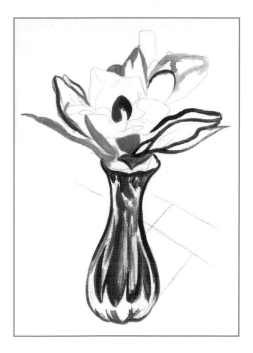

2 Define the Basic "Color Map"

First, place color in each area to create a color map you'll follow through the rest of the painting. Begin developing the warm tones in the glass vase as well.

Mix the light warm gold with Burnt Umber, Cadmium Yellow Medium and Titanium White. You can control the depth of tone by varying the amount of white you use. This color is used in the center of the vase and in some of the petals of the flower.

Create the rust color by mixing Cadmium Yellow Medium with Burnt Umber and a touch of Cadmium Red Medium. You can lighten the color a little by adding some white to it as well. This color establishes the fluted shape in the vase. Also apply it to the center of the flower.

Mix a medium green with Cadmium Yellow Medium and a touch of Prussian Blue. Add a touch of white to dull the color. Begin adding this to the leaves, outlining the leaf areas to help separate them from the petals of the flowers.

Mix another green, an olive green, using Cadmium Yellow Medium and Ivory Black. Add a touch of white to this mix to make it more of a pastel. Use both of your greens to base in the colors of the leaves. It is important to vary the types of greens you use in a floral painting; the variety creates a more natural look.

3 The Awkward Stage

Continue adding various shades of green into the leaves. Take some green down into the vase as well.

Paint some Ivory Black into the background to help create the outside edges of the petals. Paint only in the areas shown to form geometric shapes that add to the interest of this composition.

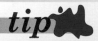 **tip**

When Painting Details, Go For the Overall Impression

When painting highly detailed subjects such as cut glass, it can be overwhelming to try to match every little shape and color you see. Instead, look at it as just nonsense shapes that create the ultimate illusion of colorful, shiny glass. As long as you get the basic shapes and direction of the colors accurate, your painting will look fine.

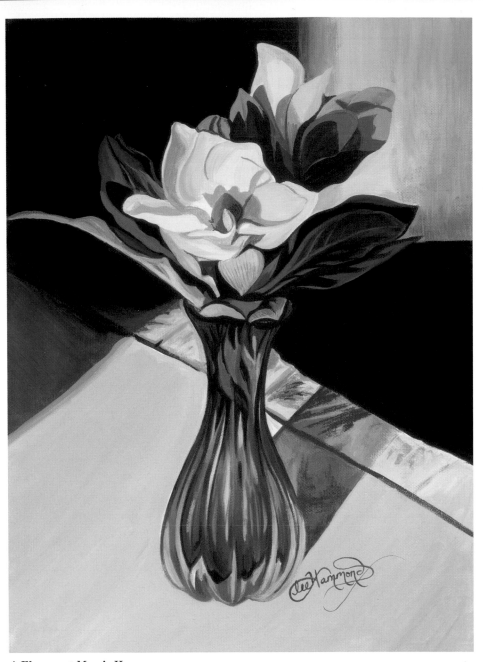

4 Finish

To mix the creamy beige color for the petals, start with Titanium White and Cadmium Yellow Medium to make a light yellow. To that, add small touches of Burnt Umber and Cadmium Red Medium. Use those dark colors sparingly; white should stay the dominant color.

With this creamy beige, base in all of the flower petals, the right side of the background, and the foreground.

Continue adding color to the vase, flowers and leaves. For fine details such as the green veins in the leaves or the brown veins in the petals, lighten the base color with white, thin the paint with water a bit to make it flow like ink, and paint the details with a no. 2/0 liner.

Add the black to the background to create the geometric patterns of the composition. On the left side, repeat the bluish green from the leaves in the background, softly blending it into the black. The gradual fading of color into black suggests distance.

Paint the shadow of the vase using beiges and greens. Be sure to use some olive green like the one you mixed in step 2 to indicate that the leaf color is reflecting into the shadow. Subtleties such as these add a lot of realism to a painting.

A Flower at Mom's House
16" × 12" (41cm × 30cm)

A Closer Look

WHILE THIS STILL-LIFE SCENE appears extremely complex and difficult, it follows all of the same procedures that we used for previous demonstrations. Look around the painting carefully and see if you can tell how I painted certain areas. The answers are below. Stop reading here and quiz yourself!

This vase is smooth, unlike the textured glass of the project before. But it is still filled with patterns and colors. Reflections are fun to paint because they don't have to be totally accurate. Look at my colors and shapes within the glass and you can see that they are very random. They are just a suggestion of the surroundings, and you don't necessarily know what they may be reflections of. The biggest spot of reflection on the right side represents a window, but the details are definitely undeveloped.

If you feel ambitious, try this painting on your own. Place a graph over my painting and draw the image on your own canvas. You can even try painting it in a monochromatic scheme, like you did for the black rose in the beginning of the chapter (see page 79). Whatever you choose to do, the main focus should be on learning and fun!

Now, for the techniques used in this painting: The reflection of the red on the tablecloth shows use of repeated colors. I painted the baby's breath with the dabbing technique. The rose petals demonstrate "light over dark and dark over light." The background is a classic example of letting the darks create the lights. And finally, the wood texture was drybrushed.

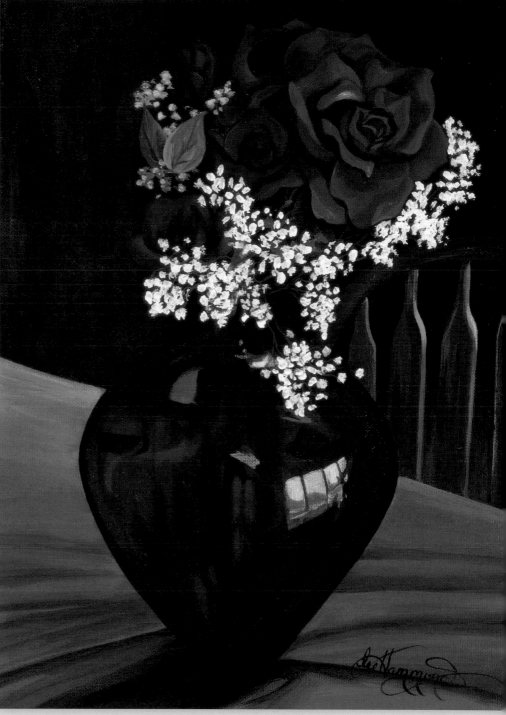

A Study in Red
16" × 12" (41cm × 30cm)

animals

ONE OF THE JOYS OF BEING AN ARTIST IS IN THE ability not only to create beautiful pictures, but also to truly capture the love we feel for nature, animals and our pets. This chapter will help you learn to draw and paint living things.

You'll learn brush and shading techniques to depict animals with all sorts of fur, from short and smooth to long and shaggy and even patterned. But don't stop there—birds, butterflies and even fish make fun subjects for painting!

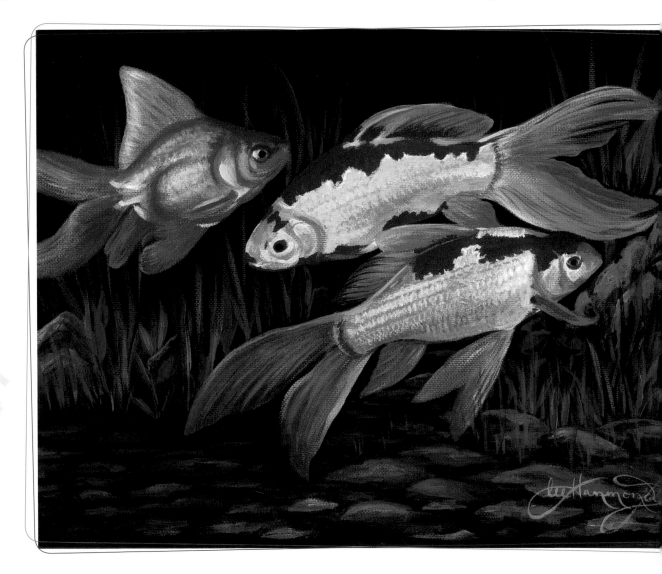

PAINTING A HORSE

The horse has been the subject of many pieces of artwork. The large animal with its strong shapes and gentle spirit is a wonderful subject for acrylic painting. For more information on how to draw horses, please refer to my book *Draw Horses* (North Light Books, 2001). We'll start simple by focusing on this horse's face.

MATERIALS LIST

Paints
Burnt Umber
Cadmium Yellow Medium
Ivory Black
Prussian Blue
Titanium White

Brushes
¾-inch (19mm) sable or
 synthetic filbert
no. 2 sable or synthetic round
no. 2/0 sable or synthetic liner

Canvas or Canvas Paper
10" × 8" (25cm × 20cm)

Other
mechanical pencil
kneaded eraser

A GRAPHED PHOTO
Use this graphed photo of a horse to begin your painting.

1 Draw the Horse
Use the grid method to create the drawing on your canvas. When your line drawing looks like mine, carefully remove the grid with a kneaded eraser.

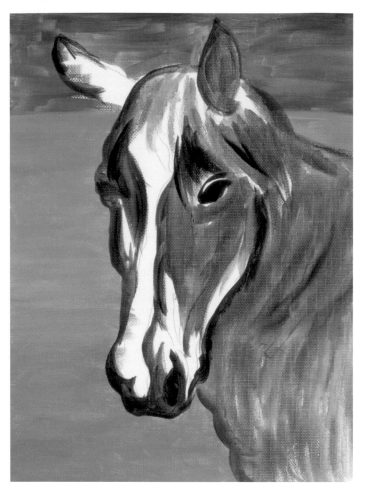 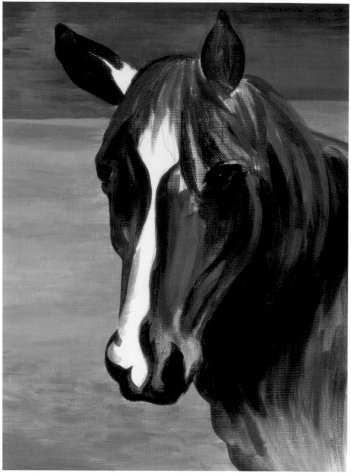

2 Block In the Color Map

Apply transparent paint with a filbert brush to cover the canvas, forming your "color map." The green in the grass area is a combination of Cadmium Yellow Medium, a touch of Prussian Blue and a dab of Titanium White. For the distant background, add more Prussian Blue to your green mixture. Block in the horse with pure Burnt Umber.

3 The Awkward Stage

Deepen the background colors, using thicker versions of the same colors you used in step 1. Be sure to completely cover the canvas.

For the horse, mix three shades of brown: a light (Burnt Umber and Titanium White), a medium (Burnt Umber) and a dark (Burnt Umber and Ivory Black). Mix a gray out of Titanium White and Ivory Black for the details on the muzzle.

With the no. 2 round brush, start to add the colors. Your strokes should follow the horse's form. The jaw is lighter than the neck; this creates the jaw edge without your having to outline it. (Remember . . . light over dark and dark over light!) Use the dark brown mixture to deepen the shadows in the ears, on the neck and under the eyes.

With black and a no. 2/0 liner, fill in the nostrils and the eyes. Use the gray in the muzzle area as shown.

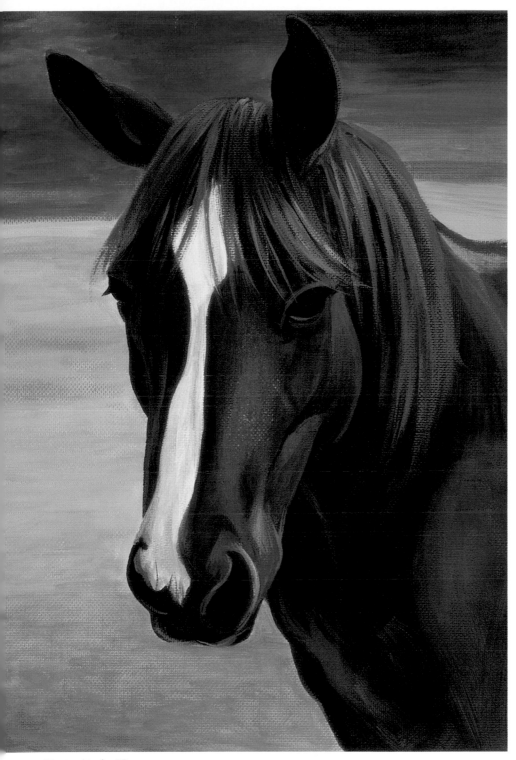

4 Finish

Finishing the painting is simply a matter of continuing to build up the paint layers to create realism. Study the photo and my painting example closely and find the small details of anatomy. These subtle details created with little tonal changes will bring the painting to life.

The muzzle, for instance, has a bit of pink in it. It is a warm pink, so mix it with Cadmium Red Medium (the warmer of the two reds on your palette) and Titanium White.

Create the mane with quick strokes of a no. 2/0 liner, following the direction of the hair's growth. Add a touch of red to the brown to give it a rusty glow. Build up the mane using many layers, and complete it with light, drybrushed highlights on the outside layers.

Portrait of a Horse
10" × 8" (25cm × 20cm)

Painting Long Fur

Those of you who have other books of mine may already know my dog Penny, my studio "art dog." She graced the cover of my colored pencil book *Drawing in Color: Animals* and has been a presence in two other books of mine. She is a fun subject to draw and paint.

Painting Penny required the same colors and techniques as the did the horse painting on the previous page. Very few things changed in the artistic process. The main difference is the need for more hair strokes, since Penny has silky long fur on her ears. The most obvious color change is in the background.

MATERIALS LIST

Paints
- Alizarin Crimson
- Burnt Umber
- Cadmium Red Medium
- Cadmium Yellow Medium
- Ivory Black
- Prussian Blue
- Titanium White

Brushes
- ¾-inch (19mm) sable or synthetic filbert
- no. 2 sable or synthetic round
- no. 2/0 sable or synthetic liner

Canvas or Canvas Paper
- 13" × 10" (33cm × 25cm)

Other
- mechanical pencil
- kneaded eraser

A Graphed Photo
Use this graphed photo of Penny to begin your painting.

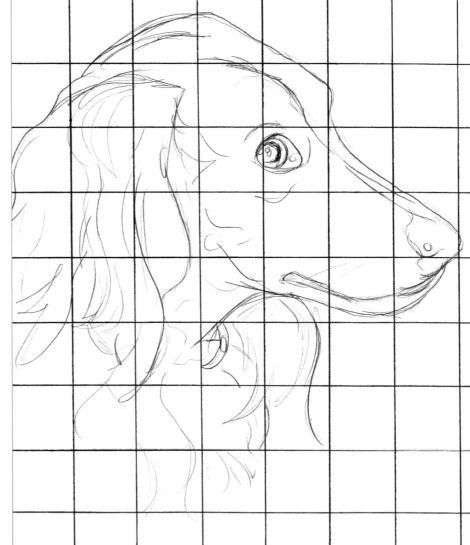

1 Draw the Subject
Draw Penny on your canvas using the grid as a guide. When your line drawing looks like mine, carefully remove the grid with a kneaded eraser.

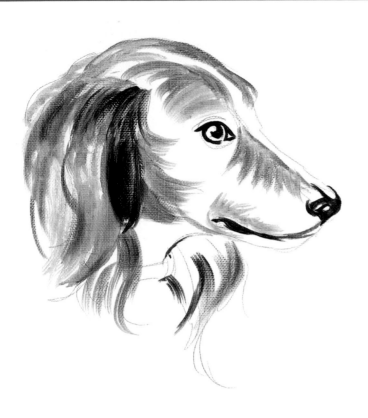

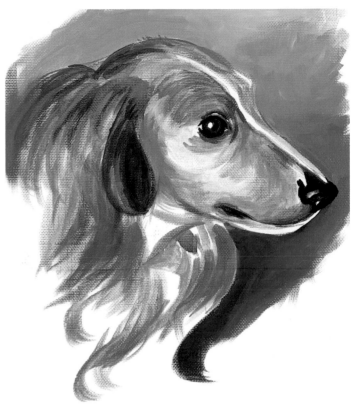

2 Block In the Base Colors

Use pure Ivory Black and a liner brush to suggest the eye. Indicate the roundness of the iris and fill in the pupil. Leave a small dot open in the pupil for the highlight that will go in later.

Fill in the nose with Ivory Black. Leave unpainted highlight areas here as well, because the nose is wet and shiny.

With the no. 2 round brush, begin blocking in the face and ear with diluted Burnt Umber. Let your strokes follow the direction of the hair. This is the first stage of layering the fur for depth. Add some of the Ivory Black to the ear to match what you see in the photo.

3 The Awkward Stage

Fill in the iris of the eye with Burnt Umber. Again, be sure to leave the small dot for the eye highlight unpainted.

Continue building up the fur with layers of color. Add some Cadmium Yellow Medium and Cadmium Red Medium to the Burnt Umber to give Penny's fur some subtle, warm highlighting, and add some white to Burnt Umber to create the light areas on her face. Continue to study the direction of fur growth and apply your brushstrokes accordingly.

Mix Prussian Blue with a touch of Titanium White for the background. Using a ¾-inch (19mm) filbert, start at the top. The background defines the edge of Penny's head. As you work down, use less white in your mix; toward the bottom, add Ivory Black to make a deep navy blue. Blend with a circular stroke to give the background color a little mottling and texture. This is a good technique for portraits of any kind, whether of people or of your favorite critter.

With Titanium White and just a touch of Alizarin Crimson, block in the pretty pink of Penny's collar with the no. 2 round brush.

Choose Background Colors to Create the Mood You Want

The blue background makes this painting feel like a studio portrait. A green background would make it look like an outdoor scene.

4 Finish

Build up the background color. Repeat the process of layering the fur colors with the no. 2 round brush to build up the thickness of fur, looking at the photo to see where the light and dark colors belong. Paint some wisps of fur over the background with quick strokes of a liner brush.

Using a liner brush with some diluted Ivory Black, create the whiskers with quick strokes.

Finish the collar by painting the ring with Ivory Black and Titanium White. Metal is easy to paint because it is just extreme patterns of dark and light.

Penny
13" × 10" (33cm × 25cm)

PAINTING FUR PATTERNS

Painting some animals is more about patterns than subtle color changes. This little tiger cub is a great combination of beautiful color and interlocking shapes. The graphing technique will really help you draw the shapes correctly.

A GRAPHED PHOTO
This tiger cub's fur is made up of many patterns and small shapes.

MATERIALS LIST

Paints
- Burnt Umber
- Cadmium Red Medium
- Cadmium Yellow Medium
- Ivory Black
- Prussian Blue
- Titanium White

Brushes
- ¾-inch (19mm) sable or synthetic filbert
- no. 2 sable or synthetic round
- no. 2/0 sable or synthetic liner

Canvas or Canvas Paper
- 8" × 10" (20cm × 25cm)

Other
- mechanical pencil
- kneaded eraser

1 Draw the Tiger Cub

Use the grid method to transfer this drawing to your canvas paper. Carefully study each square and the small shapes captured in each one. Be most careful with the shapes that create the eyes, nose, ears and paws. Don't obsess over the fur spots; if you miss some, you can create them with paint later on.

When your line drawing looks like mine, remove the grid from your canvas with a kneaded eraser.

2 Block In the Base Colors

Block in the painting with transparent applications of color to create your "color map." A green background, mixed from Cadmium Yellow Medium with a touch of Prussian Blue, will create an outdoor feel that works well for a wild animal.

Mix a transparent brown out of Burnt Umber, a touch of Cadmium Red Medium and water. Use this color to block in the head and face. Add water and a touch of Cadmium Yellow Medium to the remaining brown on your palette, and use it to base in some more of the face and the paws. Use diluted Burnt Umber under the paws. Base in the stripes and the eye, nose, ear and paw details with diluted Ivory Black.

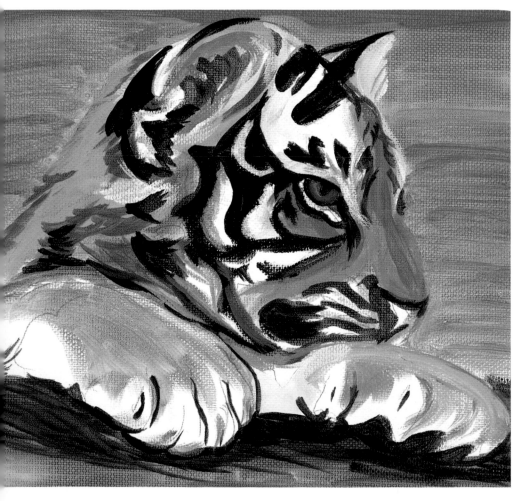

3 The Awkward Stage

Build up colors using the same colors as in step 1 but with less water. The layers you apply in this step should be thicker and more opaque. The patterns of the tiger cub now become more distinct.

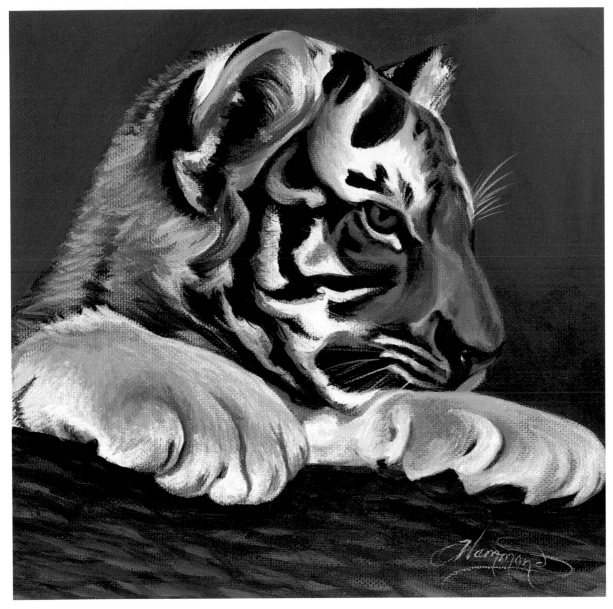

Tiger Cub
at the Zoo
8" × 10"
(20cm × 25cm)

4 Finish

This is where this little painting really comes to life. Mix a green and add a touch of Ivory Black to it to make a deep forest green. Use this to darken the background, making the light colors of the tiger cub stand out. Because red and green are complements (opposites on the color wheel), this green color contrasts nicely with the reddish hues in the cub's fur.

Build up the paint and add quick brushstrokes that show the texture of the fur. Add white whiskers and "eyelashes" with diluted Titanium White and a liner brush.

In the reference photo, someone is holding the cub. For my painting, I chose to turn the handler's arm into tree bark to make the scene look more natural. Mix three browns for the bark: Burnt Umber, Burnt Umber plus white, and Burnt Umber plus black. Layer your strokes to mimic bark texture.

FINS AND SCALES

Not all pets are furry. Some of my favorite friends are in the many aquariums I have all over my house. This is one of my fish, a calico fantail goldfish. You'll be surprised at how quick and easy this little project is.

MATERIALS LIST

Paints
Cadmium Red Medium
Cadmium Yellow Medium
Ivory Black
Prussian Blue
Titanium White

Brushes
¾-inch (19mm) sable or
 synthetic filbert
no. 2 sable or synthetic round
no. 2/0 sable or synthetic round

Canvas or Canvas Paper
12" × 16" (30cm × 41cm)

Other
mechanical pencil
kneaded eraser

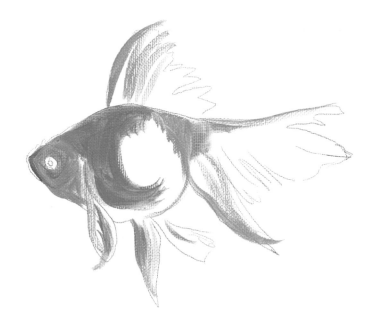

1 Draw the Fish
Use the grid method to draw the outline of the fish on your canvas paper. When your outline looks like mine, remove the grid lines with your kneaded eraser.

2 Paint the Base Colors
Mix a pretty orange color with Cadmium Yellow Medium and Cadmium Red Medium. With a no. 2 round brush, apply the orange to the fish's back, belly and tail.

Mix a medium gray out of Ivory Black and Titanium White. Still using the no. 2 round brush, apply the gray to the fish's face and begin painting in the details of the fins.

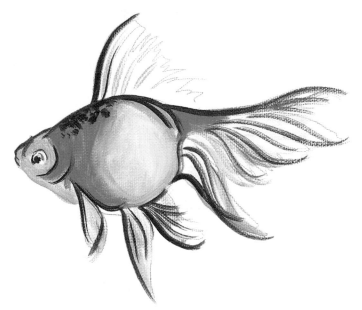

3 The Awkward Stage

Take some of the orange mix you used in step 2 and add more yellow and white to it for a lighter orange color. Use this to paint the rest of the fish's belly. The lighter color seems to make the belly protrude.

Add dark details to make the fish look real. Just a few black dabs and lines bring the fish to life. Paint the flowing fins with Ivory Black thinned with water.

4 Fin-ish!

A blue-green background will make this fish look like he is floating in water rather than air. Take some Titanium White and mix in a very small amount of Prussian Blue. Then add just a dab of Cadmium Yellow Medium to create the aquamarine color. Paint the background, and also paint some aquamarine within the fins to make them appear transparent.

This species of goldfish is puffy, and its abdomen should appear very round. To achieve this, mix a little gray into your orange and paint a shadow edge along the abdomen.

Continue dabbing the dark "calico" spots into the body of the fish. Just for fun, add some bubbles. Look closely, and you will see that they are nothing more than tiny spheres.

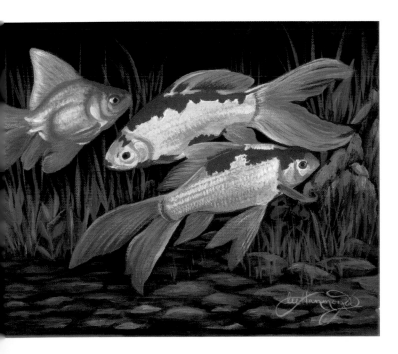

AN UNDERWATER LANDSCAPE

If one fish is good, a tank full of fish is even better. Fish are so beautiful the way the colors dance off of them. Aquarium greenery is quite similar to the leaves you've already painted in landscapes and floral still lifes.

Look around and you will find that even ordinary things in life, things we take for granted, can be subjects for creative and enjoyable art. If you feel adventurous, try this painting yourself! If you like, you can add a few different fish species by looking at photos in books about fish. You can create your own aquarium scene!

My Aquarium
12" × 16" (30cm × 41cm)

MONARCH BUTTERFLY

A whole book could be written on painting butterflies. I make a point each summer to search for them and take as many photos as possible. They're so beautiful, and the artistic possibilities are endless.

This is a great project for a beginning painter. The wings and patterns are seen straight on and are easy to draw using the grid method.

MATERIALS LIST

Paints

Alizarin Crimson
Cadmium Red Medium
Cadmium Yellow Medium
Ivory Black
Prussian Blue
Titanium White

Brushes

¾-inch (19mm) sable or synthetic filbert
no. 2 sable or synthetic round
no. 2/0 sable or synthetic liner

Canvas or Canvas Paper

14" × 11" (36cm × 28cm)

Other

mechanical pencil
kneaded eraser

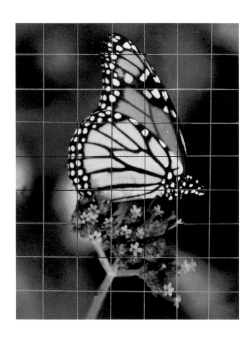

A GRAPHED PHOTO

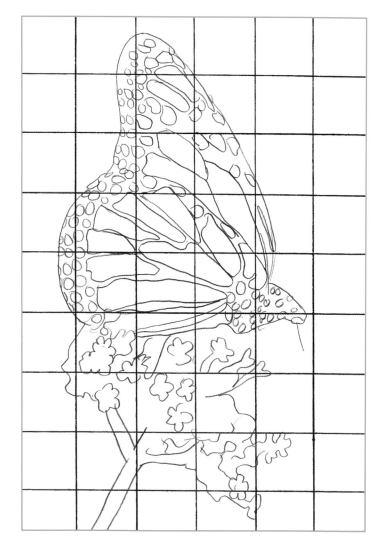

1 Draw the Butterfly

Use the grid method to draw the outline of the butterfly on your canvas. When your outline looks like mine, remove the grid lines with a kneaded eraser.

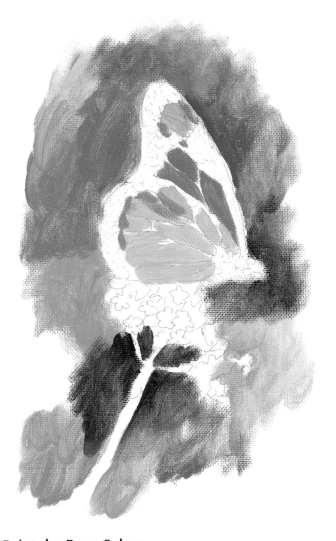

2 Paint the Base Colors

This very colorful background is almost as important to the
painting as the butterfly itself. Use a multitude of colors, and
scrub each one in with circular strokes of a flat brush. Most of
these are pastel colors, which means Titanium White has been
added to the mix. Experiment with the colors.

Block in the dark orange areas on the butterfly with an
orange mixed from Cadmium Red Medium and Cadmium
Yellow Medium. For the lighter orange areas, add a touch of
Titanium White to the orange mix.

3 The Awkward Stage

Once the orange areas of the butterfly are complete, paint
Titanium White on all of the spots. Then dilute some Ivory
Black with water to an ink-like consistency and add the black
details with a no. 2/0 liner brush. With the addition of the black
details, you begin to see the beauty of contrast!

Fill in the flower stem with a green mixed from Prussian
Blue, Cadmium Yellow Medium and Titanium White. Mix an
olive green using Ivory Black and Cadmium Yellow Medium
and dab this on to create the heads of the flowers.

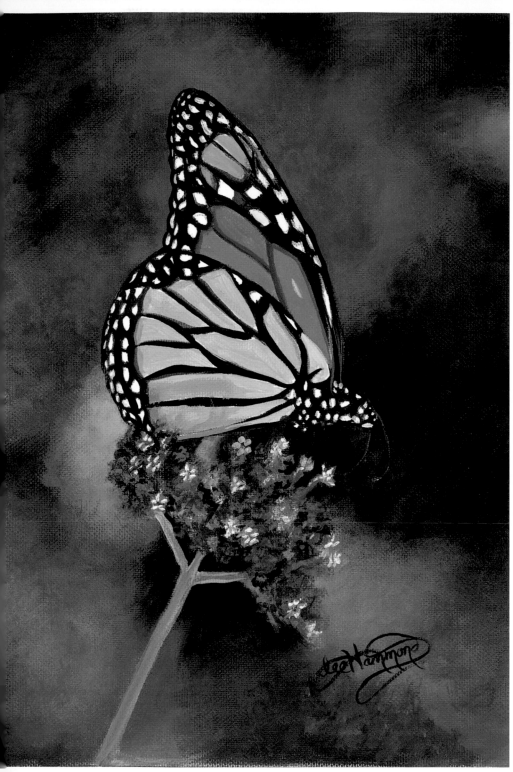

4 Finish

Build up additional layers of color. Add flower details with a small no. 2/0 liner brush and Alizarin Crimson and Titanium White. The light colors seem to dance against the dark background.

To finish, scrub layer after layer of different colors into the background, making sure that the transitions of color are smooth. This kind of blurred background makes it look as if there is something in the background, but that it's simply out of focus. This lets the viewer focus on the main subject, the butterfly.

Monarch on the Lilac Bush
14" × 11" (36cm × 28cm)

PAINTING FEATHERS

Birds are beautiful creatures to paint. I like to use birds in my artwork because there are so many different shapes, sizes and colors of birds. In fact, I created an entire book about drawing them in colored pencil, called *Birds*, part of the Drawing In Color series (North Light Books, 2001). The photos and color explanations in that book could easily be used to paint from as well.

I like the pose of this red-tailed hawk because of the strength it portrays. This poor bird was injured and can no longer fly; fortunately, it is living out its life at a zoo. Zoos and raptor centers are great places to take photos and find reference material.

MATERIALS LIST

Paints
- Burnt Umber
- Ivory Black
- Titanium White
- Cadmium Yellow Medium
- Cadmium Red Medium
- Prussian Blue

Brushes
- ¾-inch (19mm) sable or synthetic filbert
- no. 2 sable or synthetic round
- no. 2 sable or synthetic liner

Canvas or Canvas Paper
- 16" × 12" (41cm × 30cm)

Other
- mechanical pencil
- kneaded eraser

A GRAPHED PHOTO

1 Draw the Hawk

Use the grid method to draw the outline of the hawk. When your outline looks like mine, remove the grid lines with a kneaded eraser.

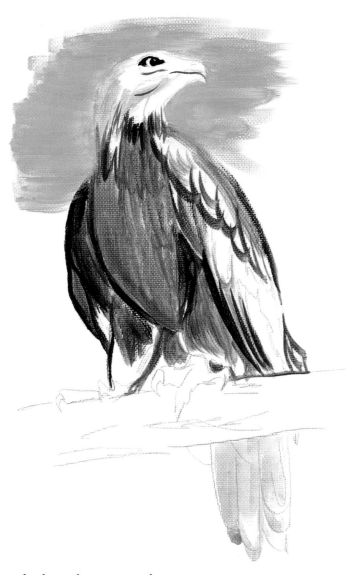

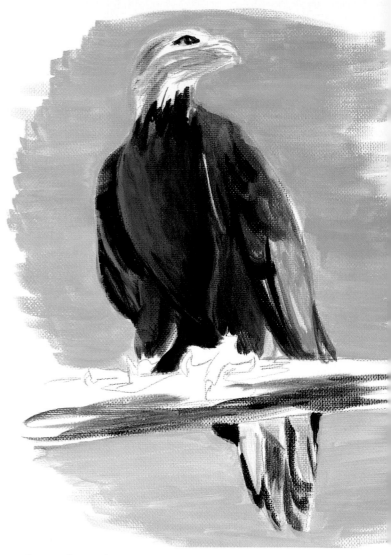

2 Block In the Base Colors

Start the background with a sky blue color mixed from Titanium White and a touch of Prussian Blue. Use the ¾-inch (19mm) filbert brush and paint the background with horizontal strokes.

With Ivory Black, paint the shape of the eye. Use the liner brush for more control. Use a diluted mixture of Ivory Black and Burnt Umber with a no. 2 round brush to block in the hawk's body and wings. Your strokes should start to create the shapes of the feathers, giving you something to follow in later steps.

3 The Awkward Stage

Build up layers of paint using more-opaque mixtures of the same colors as in step 2. Keep defining the feather shapes with your brushstrokes. Begin to develop the shadows, which are located under the face, under the wings and on the underside of the tree limb. Don't worry if your painting looks sloppy; "the awkward stage" is just part of the process.

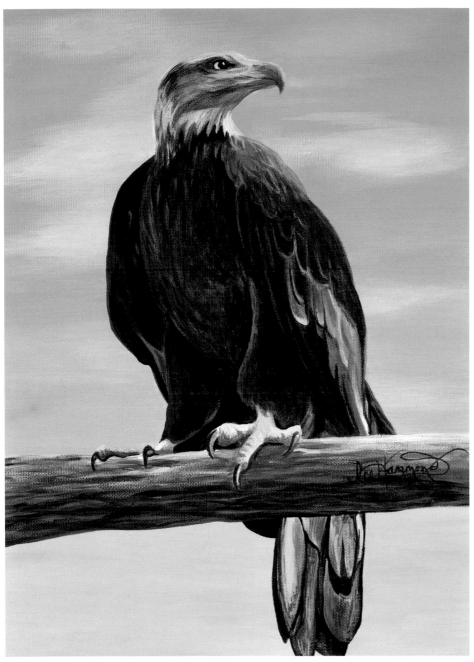

Proud Hawk
16" × 12" (41cm × 30cm)

4 Finish

Now you'll start to tackle the details. Don't be afraid; take your time and literally draw each shape with paint, one at a time. The liner brush is helpful in this step.

Study the photograph and look for all the small areas of color that are layered on top of each other. For example, the feathers of the chest stand out against the dark brown beneath. The details of the wings are layered on top of the darkened Burnt Umber you painted in step 2. This ability to layer colors is what makes acrylic painting so wonderful!

Add touches of Cadmium Yellow Medium and Cadmium Red Medium to Burnt Umber to create a warm brown. Use this color in the chest feathers, on the bottoms of the feet and on the tree limb. Add some Cadmium Yellow Medium to the eye.

For the edges of the feathers, add a touch of Titanium White to Burnt Umber. Paint along every feather edge to separate them, making them look almost like shingles on a roof.

Keep working, comparing your painting to the photograph, and see how many little details you can capture. Look at my finished painting and you'll see that I often simplified areas, especially those in shadow. It may take time and many layers to get your painting where you want it, but that's okay. As I tell my students, it is all in the "doing"!

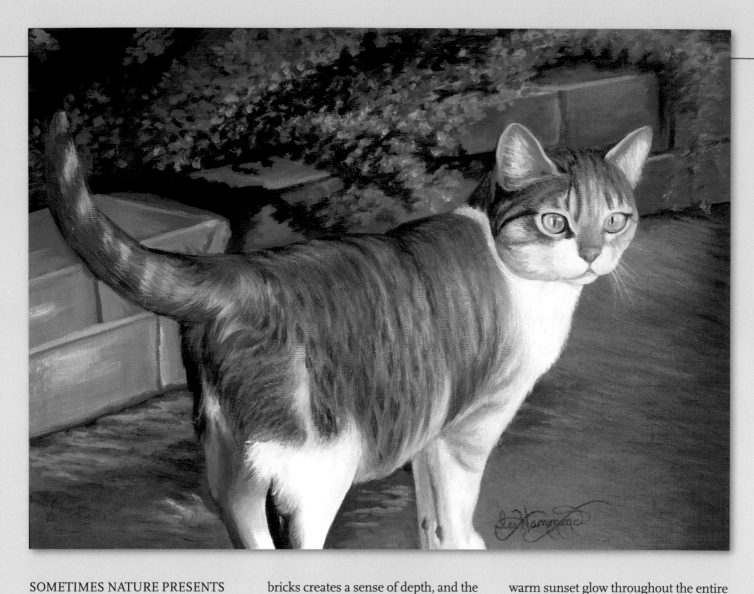

Mindy in the Sunshine
9" × 12" (23cm × 30cm)

SOMETIMES NATURE PRESENTS the artist with almost magical opportunities to paint. The scene in this painting was one of those times for me. I love this painting of my kitty for many reasons. First, I think Mindy is a cutie, and her face makes me smile. Artistically, her fur is a beautiful combination of colors and patterns that was challenging yet fun to create. Compositionally, the angle of the bricks creates a sense of depth, and the plants cascading over the bricks act like a subtle frame surrounding the kitty's head.

But what I love most of all about this painting is the color scheme. The complementary colors make this painting really stand out. Look at how the red tones contrast against the greens. The golden tones within the reds create a warm sunset glow throughout the entire piece.

Wherever you go, carry a camera so that you can capture moments such as this when subject, composition and color all come together perfectly!

See the details on the facing page to fnd out how I painted this. Try it yourself!

HIP

To create fur that is made up of many colors and patterns, you need to paint layer upon layer upon layer. The beauty of acrylic paint is the ability to continually add colors and build up layers. Look at how the paint strokes create the patterns and direction of the kitty's fur.

BRICKS AND BUSHES

I used a dabbing stroke to create the bushes. I began with the dark tones, then added the lighter colors in layers, dabbing each one to create texture.

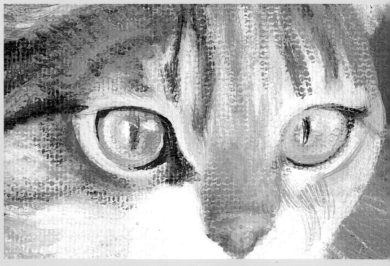

EYES

See how shiny these eyes look? I used multiple colors to give them depth and then added the white highlights to make them shine.

GROUND

I used the dry-brush technique here, building up the colors of the ground in layers. Always follow the direction of the surface when applying your strokes. I applied these strokes diagonally to give the illusion of distance.

people

NOTHING IS MORE REWARDING THAN CREATING A realistic portrait of a special person. I have specialized in portraiture for my entire career. I've created thousands of portraits of children, families, presidents and NASCAR drivers. My composite sketches and forensic illustrations help law enforcement officials capture criminals and solve "John Doe" mysteries. My first book was *How to Draw Lifelike Portraits From Photographs* (North Light Books, 1995). While people are a popular subject for a lot of artists, they are also considered one of the hardest subjects to portray in art.

The difficulty comes from the need to be totally accurate. If anything about the portrait is not right, the likeness of the person is lost. I always suggest that my students try drawing portraits before they attempt to paint them. Drawing is the best way to get a good solid understanding of facial anatomy. This chapter will give you some experience with portrait painting. You'll learn how to mix good hair and skin tones and what to look for in the anatomy of a face.

Painting Skin Tones

I start with the same basic skin tone mix for all skin tones, but I alter the formula depending on the depth and tone of the complexion I am creating. Here's how I do it.

Basic Mix for Skin Tones
Titanium White + dab of Cadmium Yellow Medium + dab of Cadmium Red Medium + touch of Burnt Umber

Warmer
Basic Mix + more Cadmium Red Medium

Darker
Basic Mix + more Burnt Umber

Olive
Basic Mix + more Cadmium Yellow Medium + Prussian Blue

Cooler
Basic Mix + touch of Prussian Blue

Very Dark
Basic Mix + more Burnt Umber

Golden
Basic Mix + touch of Cadmium Yellow Medium

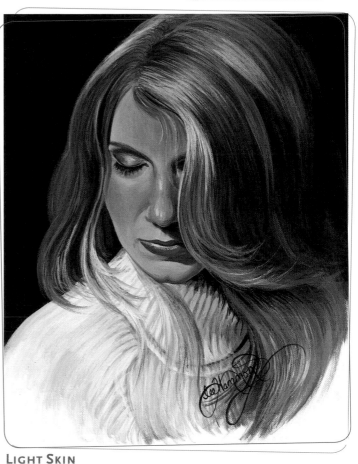

Light Skin

My daughter LeAnne has a very pale complexion, and in this light it took on a very pink cast. I added a touch of Alizarin Crimson to the basic skin tone mixture to make it pinker. For the shadow areas, I darkened the basic mixture with touches of Alizarin Crimson and Burnt Umber. This makes a cool shadow, which will appear to recede. For highlight areas such as the nose, I used Cadmium Red Medium because warmer colors tend to come forward.

Portrait of LeAnne
16" × 12" (41cm × 30cm)

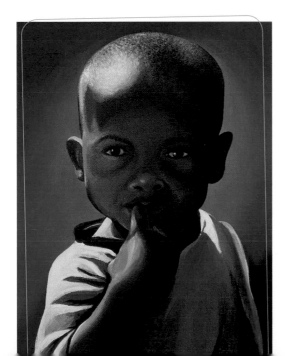

Dark Skin

I painted this boy's skin with the same colors as in the other portrait, but I used much more Burnt Umber and Alizarin Crimson in the skin tone mixture to make his complexion deep. As with LeAnne's portrait, I made the mix cooler in the shadows and warmer in the highlights. This is well illustrated in the boy's forearm.

A Little Boy in Africa
12" × 9" (30cm × 23cm)

Exercise: Paint Different Types of Hair

When painting hair, it is very important that your brushstrokes go with the direction of the hair itself. It is also important to develop the hair using many, many layers. Whether it's thick or thin, hair is made up of thousands of strands. If your real hair has 10,000 strands, it will be impossible to accurately depict it in a painting with a couple of strokes. Keep building color, layer after layer, and the hair will look realistic. LeAnne's hair on page 113 is a perfect example. Look at the painting, and you can see the many brushstrokes, from dark to light. Highlights are added last to create the shine.

For tightly curled hair like that of the boy on page 113, you don't have a hair direction to follow. Rather, you have a texture. Create this kind of hair with a dabbing dry-brush technique.

Straight or Wavy Hair

1 Start LeAnne's hair with long strokes of a no. 2 round brush following the direction of the hair. Paint the darkest tones first.

2 Fill in the hair with quick, tapered strokes. You'll need to paint many layers.

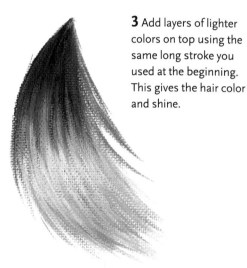

3 Add layers of lighter colors on top using the same long stroke you used at the beginning. This gives the hair color and shine.

Tightly Curled Hair

1 Start with a single, scrubbed-in layer. Use a no. 2 round.

2 Add paint with a dabbing technique, holding the brush perpendicular to the canvas.

3 Add lighter tones using the same dabbing technique.

Exercise: Paint Facial Features

Let's practice painting some generic facial features with a monochromatic color scheme. Start with the nose, because it is the least complicated of the features and most closely resembles a sphere. The mouth will be a bit more difficult than the nose because the shapes are more complex. The eyes will be the biggest challenge. They have many small shapes and details that are important to capture accurately. I love painting eyes because of their beauty and the way they reflect emotion.

Nose

1 "Draw" the shapes in with a liner brush and a medium gray. This is the start of the overall form.

2 With a no. 2 round, add more medium gray to create the skin tone. Keeping a sphere in mind, let your strokes create the roundness of the nose.

3 Refine the contours with various shades of gray. Use darker grays for the nostrils and shadows. Use pure Titanium White for the highlights.

Mouth

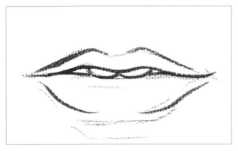 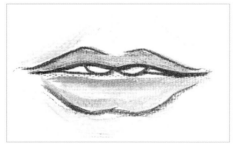 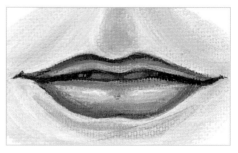

1 "Draw" the shapes in with a liner brush and a medium gray. These shapes are more complex than those of the nose.

2 With a no. 2 round, add medium and light gray for the skin tone. Use lighter gray across the middle of the lower lip to make it look rounded.

3 Deepen the skin tones. Use dark gray inside the mouth, and suggest teeth with black and a liner brush. Resist the temptation to make the teeth white; the inside of the mouth in shadow. Highlight the skin with white and light gray.

Eyes

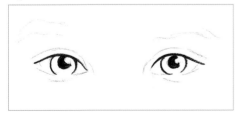 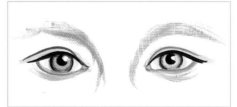 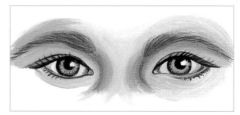

1 It's very important for the irises and pupils to be perfect circles, so draw them with a circle template or stencil. (This rule changes if the eye is not looking straight ahead.) Leave an unpainted area for the catchlight, placing it half in the pupil and half in the iris. "Draw" the shapes in with a liner brush and Ivory Black.

2 With medium gray, begin placing tone to create the curve of the brow and the shape of the eye. Add some tone to the irises.

3 Add more medium gray skin tone. Use both light and dark tones on top of that to create the form. Add small details to the irises to make them sparkle. For the eyebrows and eyelashes, use diluted paint and very quick strokes with a liner brush. This will create small tapered lines.

PAINT A MONOCHROMATIC PORTRAIT

I have drawn Abraham Lincoln for many of my portrait books. For me, no other face has so much character in it. The photo below is a favorite of mine that shows Lincoln in his later years. The weathered look of his face is evident, and the wrinkles of age apparent. Since this is a vintage photograph, I thought it would be a good portrait to do in sepia-like tones.

MATERIALS LIST

Paints
 Burnt Umber
 Titanium White

Brushes
 ¾-inch (19mm) sable or synthetic filbert
 no. 2 sable or synthetic round
 no. 1 sable or synthetic liner

Canvas or Canvas Paper
 12" × 9" (30cm × 23cm)

Other
 mechanical pencil
 kneaded eraser

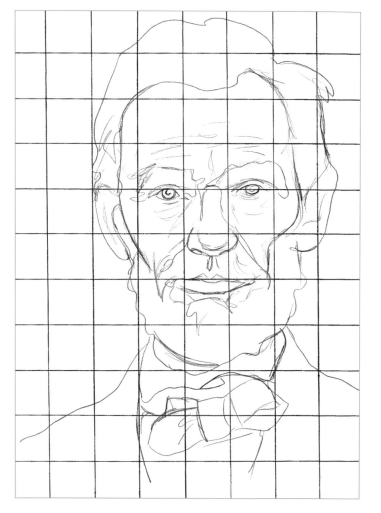

A GRAPHED PHOTO
Use this graphed photo to begin your painting.

1 Draw the Face

Draw the face on your canvas paper. Don't feel the need to capture every small wrinkle and detail. You will be creating that detail with paint. When your line drawing looks like mine, carefully remove the grid with a kneaded eraser.

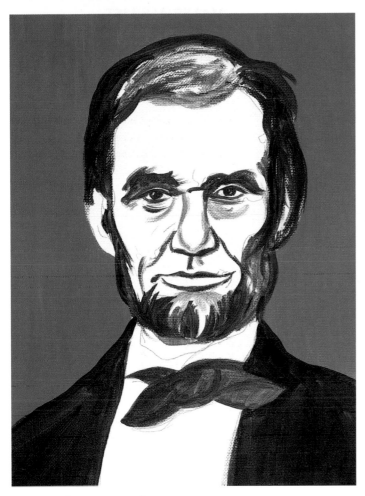 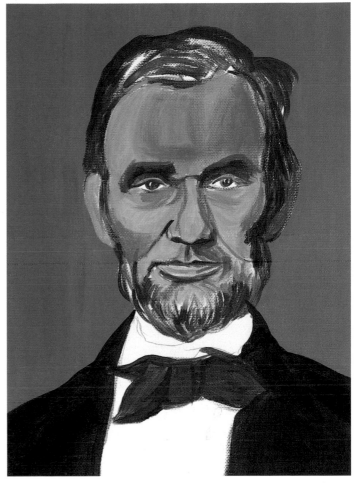

2 Paint the Base Colors

With the ¾-inch (19mm) filbert brush, fill in the entire background with a mix of Burnt Umber and Titanium White. This should be a medium brown, one that will contrast against both light and dark colors.

With pure Burnt Umber and your no. 2 round brush, fill in the jacket, tie and the dark areas of the face, beard and hair as seen here.

"Draw" with your liner brush to create the features of the face. Refer to the exercises on page 115 to refresh your memory on how to draw facial features.

3 The Awkward Stage

Base in the color of the face using a color similar to the background. Add a touch of Titanium White to the mix, then paint the highlight areas. Remember, this is just to cover the canvas and give us a foundation on which to build details.

4 Finish

As you finish the painting, refer often to the photograph.

Use the round brush to fill in the hair and beard with more pure Burnt Umber. Use the liner brush to add subtle light brown highlights. Remember to follow the hair direction.

With Burnt Umber, work on the eyes, darkening the shadows and making the eyebrows hairier. Add highlights to the eyebrows with light brown, just as you did the hair and beard.

Develop the nose and mouth for more realism, paying particular attention to the shadows and reflected light. Remember the five elements of shading (see page 28) and refer to the exercises on page 115 if you need help.

Continue to add small details in many layers, using light, medium and dark shades of Burnt Umber. Look at the tie, and you can see how these three shades created the realism of the fabric. Use shades of white, darkened with Burnt Umber, to create the definition on the shirt. Although it is a white shirt, it should not be left pure white.

Abraham Lincoln
12" × 9" (30cm × 23cm)

WOMAN'S PORTRAIT IN COLOR

This photo of my daughter LeAnne is a good one for practicing painting a face in color. The close-up pose combined with good lighting makes the features and colors easy to see. This portrait may look difficult, but you can do it if you take your time, start with an accurate drawing, and paint the facial features one at a time. When you are done, you will have a finished portrait!

MATERIALS LIST

Paints

Alizarin Crimson
Burnt Umber
Cadmium Red Medium
Cadmium Yellow Medium
Ivory Black
Titanium White

Brushes

¾-inch (19mm) sable or synthetic filbert
no. 2 sable or synthetic round
no. 1 sable or synthetic liner

Canvas or Canvas Paper

16" × 12" (41cm × 31cm)

Other

mechanical pencil
kneaded eraser
circle template or stencil

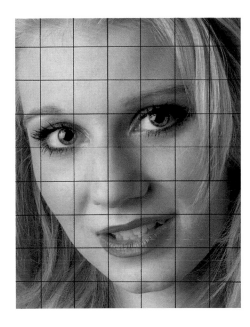

A GRAPHED PHOTO

Use this graphed photo to begin your painting.

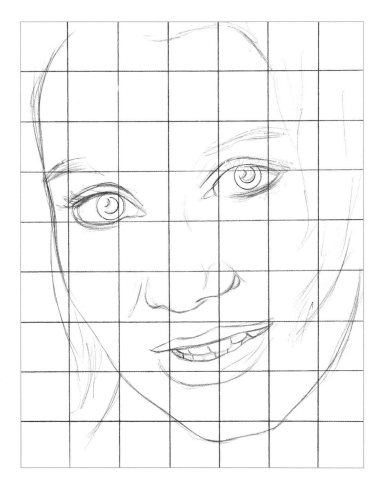

1 Draw the Face

Using the grid method, draw the face on your canvas paper. When your line drawing looks like mine, carefully remove the grid with a kneaded eraser.

2 Block In Skin Tones

With a round brush and the basic skin tone mix that we talked about on page 113, block in the tones around the nose and mouth. Leave the lips alone so you don't lose their definition.

3 The Awkward Stage

Take the skin tone mix from step 1 and add touches of Alizarin Crimson and Cadmium Red Medium. This is for the shadow color along the side of the nose and the base color of the lips. Use the round brush to apply and layer these colors into the painting.

Now add some Burnt Umber to the mix and paint the cast shadows on the right side of the nostril and under the nose. Also place some of this color on the inside corners of the mouth and start to detail the lips.

4 Finish the Mouth and Nose

Use a liner brush and the basic skin tone mix to paint separations between the teeth. Study the photograph and continue to layer in small details with the liner brush. Use light, medium and dark tones for realism. Look for the subtle shadow on the left side of the nose and the highlight on the nose's tip. Also notice the shadows under the nose that almost meet the lip, and the small creases in the lips. You can see why I call this "drawing with a brush."

5 Start the Eye Area

Use a circle template or stencil to make the irises and pupils perfect circles. (The pupil and iris are perfect circles only if the eyes are looking directly at you.)

With a round brush and the basic skin tone mix described on page 113, fill in the area around the eyes. Use a small amount of Burnt Umber on a liner brush to carefully "draw" the outside edges of the eyes and eyebrows.

6 The Awkward Stage

Create a light olive green by mixing Cadmium Yellow Medium with a touch of Ivory Black and some Titanium White. Use the liner brush to fill in the irises with this color. Fill in the pupil with pure Ivory Black, leaving a small dot for the highlight. (This is also known as a catchlight, and it should always be placed half in the iris and half in the pupil.) LeAnne has a dark edge around her irises, so apply a touch of black with the liner brush. Also outline the eyelids.

There is a hugely important detail that is often left out of the eye in artwork, and that is the edge or thickness of the lower lid. LeAnne has a very prominent edge here. It will look even more prominent when you add dark lashes in the next step.

With the shadow colors described in step 3, begin defining the areas beside the bridge of the nose and above the eye and eyelids.

7 Finish the Eyes

Continue to develop the eye details. Notice that the white of the eye (also known as the sclera) is not pure white. I have shaded the whites of the eyes with some light gray and basic skin tone mix to make them look rounded. These colors are deeper on the right side due to the shadows.

Long, sweeping eyelashes are a striking part of LeAnne's appearance. I suggest practicing eyelashes on a scrap piece of canvas paper first. It takes very thin paint and quick strokes of the liner brush to make the lines taper. Also note how the eyelashes grow in little clumps, and appear longer at the outside edges.

Add a quick stroke of white to the catch light area to make the eyes sparkle and look moist.

8 Finish the Portrait

Now it is time to put all of this together by adding the hair. Blonde hair is made up of many colors all layered together. You can see where I have used Cadmium Yellow and Cadmium Red for a reddish hue as well as Burnt Umber and Ivory Black for deep shadows.

With the round brush, base in the reddish color first. Then layer all of the other colors on top of that. Paint the light blonde highlights last, and extend them over the side of her face. Be sure to use long strokes that follow the direction of the hair. Remember, hair must be built up in many layers to look natural.

It is not necessary to try to match the photograph at this point. The hair is just a framework to make you look at the face, and is supplemental to the portrait.

LeAnne
16" × 12" (41cm × 31cm)

PAINTING CLOTHING

In this project you'll get an introduction to painting clothing. Fabric is a challenge to paint because it moves and conforms to the shape of the body. In this piece, it is interestingly lit, with extreme lighting and shadows.

You can get more practice with painting the face by using the grid method with the finished portrait on the next page to draw the entire figure on your canvas; however, for this exercise, I will concentrate just on the jacket.

MATERIALS LIST

Paints
 Alizarin Crimson
 Titanium White
Brushes
 ¾-inch (19mm) sable or synthetic filbert
 no. 2 sable or synthetic round
 no. 1 sable or synthetic liner
Canvas
 12" × 10" (31cm × 25cm)

1 Sketch, Then Start Painting the Basic Shapes

Sketch the overall shape of the jacket. Use a grid if you'd like. The jacket is made up of many odd shapes and curved lines.

Use a liner brush and Alizarin Crimson to "draw" in the basic shapes. Then, with a no. 2 round brush, start to fill in the jacket with a medium pink mixture made from Alizarin Crimson and Titanium White.

2 The Awkward Stage

Once the entire jacket is filled in with the medium pink mixture, create a darker pink and begin to fill in the shadow areas of the jacket. Look at the finished example on the next page as a guide. Now mix a very light pink and paint the highlight areas where the fabric protrudes.

At this stage, the paint still looks a little transparent, but don't stop now!

3 Finish

Keep applying layers of paint, placing the lights and darks as shown. The light is coming from the upper left, which determines where the shadows are. The shadows on the jacket are created not only by folds in the fabric, but also by the arm and the leg blocking the light.

If you want to paint the entire pose, create the blue jeans using the same process with Prussian Blue and Titanium White.

A Casual Pose
12" × 10" (31cm × 25cm)

Practice on Magazine Pictures

Magazines contain lots of photos of clothing of all fabrics and styles. Graph a photo, create a drawing on your canvas and use it for practice. This is a great way to get more experience painting creases, folds and all kinds of fabrics.

A Closer Look

THE CLOTHING WORN FOR A portrait tells us a lot about the subject's personality. In this painting, the jean jacket adds ruggedness, making this man appear to be an outdoorsman. If I had painted him in a shirt and tie, it would have changed his whole personality.

The extreme use of shadows makes this painting intense. Look at the way the light plays off of the man's face and illuminates the front of the jacket. Also notice all of the bright highlights on the face. This painting is a real challenge!

If you want to try painting this portrait yourself, place a grid of ½-inch (13mm) squares over this portrait. Then place a grid of 1-inch (25mm) squares on your canvas. This will make your painting twice the size of this reproduction. Really study the colors and try to re-create them. Refer to the portrait of LeAnne on page 121 for the skin tones. Refer to the painting on page 123 for the clothing. The painting processes in both of those examples are very similar to what you would use for this painting.

Sam
11" × 7" (28cm × 18cm)

Conclusion

I hope you have enjoyed reading this painting book as much as I have enoyed creating it. I feel very fortunate to be branching out, teaching my painting techniques as well as the drawing methods I have long taught.

It is a wonderful feeling for me as a writer and illustrator to know that my work will continue on with my readers. I have made so many wonderful friends through my career as an artist. Many of these friends I have shared time with; others I have never met. I'm looking forward to making many more!

My goal as a writer, however, has never been fame and fortune. It is simply to share something I love with others. I am passionate about my art. It is not just what I do; it is who I am.

I hope art becomes as important to you, too. Good luck to you always!

A Tribute to Our Military

Two years ago, my son-in-law went to Afghanistan as an army ranger. I tied this plastic yellow ribbon around my gaslight in my front yard, where it will stay until he comes home for good. It is now tattered and torn and becoming worn out, much like many of the men and women who are defending our freedom.

This is for all of the brave souls who so courageously give of themselves to protect the honor and freedom of others. My wish for the world is that no more yellow ribbons would ever have to be tied.

Index

Get inspired to paint and draw with these other fine North Light Books!

Lee Hammond's Big Book of Drawing

by Lee Hammond

ISBN-13: 978-1-58180-473-7
ISBN-10: 1-58180-473-3
Paperback, 240 pages, #32741

With Lee Hammond's easy methods, anyone can draw beautiful landscapes, still lifes and portraits in pencil and colored pencil. Learn the simple secrets to creating realistic drawings with this project-packed book.

Drawing Realistic Pets From Photographs

by Lee Hammond

ISBN-13: 978-1-58180-640-3
ISBN-10: 1-58180-640-X
Paperback, 128 pages, #33226

Turn your photographs of your beloved pets into lifelike drawings! Lee Hammond's foolproof drawing methods make it easy for anyone to draw cats, dogs, birds, bunnies and many more pets.

Painting With Brenda Harris, vol. 3: Lovely Landscapes

by Brenda Harris

ISBN-13: 978-1-58180-739-4
ISBN-10: 1-58180-739-2
Paperback, 112 pages, #33416

You can create a beautiful landscape painting in just a few hours with TV painter Brenda Harris. The ten step-by-step projects in this book correspond to the paintings in Brenda's PBS television series. Project patterns make it easy, even if you're a beginner.

The Drawing Bible

by Craig Nelson

ISBN-13: 978-1-58180-620-5
ISBN-10: 1-58180-620-5
Hardcover with wire-o binding, 304 pages, #33191

In this definitive drawing resource, Craig Nelson shows you how to draw with all of the most popular mediums, including pencil, charcoal, pastels, colored pencils and more. Packed with drawing demonstrations and inspiration for artists!

The Ultimate Guide to Painting From Photographs

edited by James Markle and Layne Vanover

ISBN-13: 978-1-58180-717-2
ISBN-10: 1-58180-717-1
Paperback, 208 pages, #33389

All you need to create a great-looking painting is a favorite photo, a few basic materials and this book. Includes 40 step-by-step projects on a variety of painting subjects in watercolor, oil, acrylic and pastel.

These books and other fine North Light titles are available at your local fine art retailer or bookstore or from online suppliers.